POSTCARD HISTORY SERIES

The Kennebunks
in Season

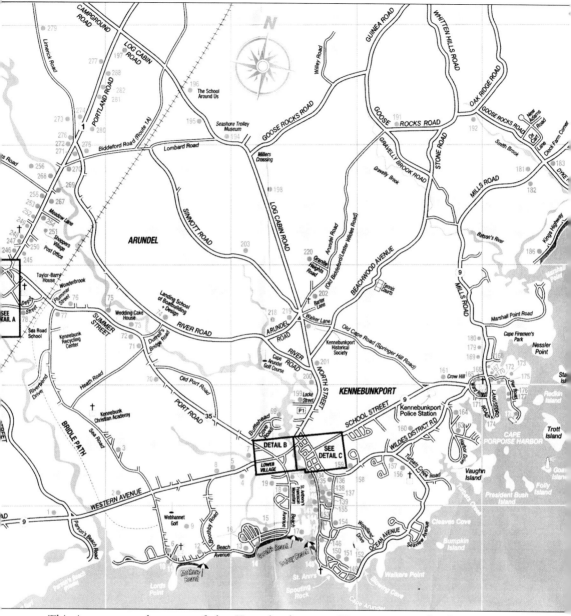

This is a present-day map of the Kennebunks area. (Courtesy Kennebunk/Kennebunkport Chamber of Commerce.)

POSTCARD HISTORY SERIES

The Kennebunks in Season

Steven Burr

ARCADIA
PUBLISHING

Published by Arcadia Publishing,
Charleston, South Carolina

Printed in the United States of America

Library of Congress Catalog Card Number: 2005920024

For all general information, contact Arcadia Publishing:
Telephone 843-853-2070
Fax 843-853-0044
E-mail sales@arcadiapublishing.com
For customer service and orders:
Toll-Free 1-888-313-2665

Visit us on the Internet at www.arcadiapublishing.com

To my mom, Frances Burr.

CONTENTS

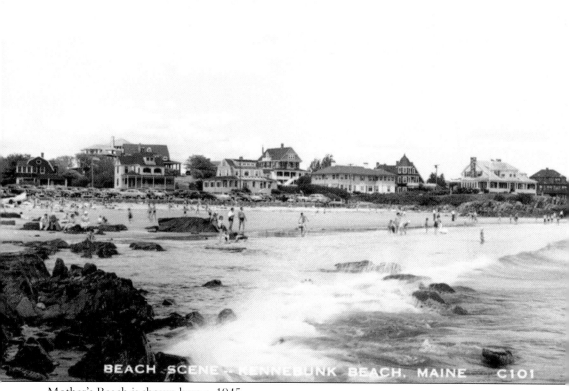

BEACH SCENE - KENNEBUNK BEACH, MAINE C101

Mother's Beach is shown here *c.* 1945.

INTRODUCTION

In 1870, Samuel Damon, Richard Hodgdon, Charles Goodwin, and John Townsend Trowbridge of Arlington, Massachusetts, shared a vision of turning Kennebunkport, Maine, into a first-class summer resort. To accomplish the task, they created the Boston and Kennebunkport Sea Shore Company. These men then joined forces with five other Massachusetts business associates and two Kennebunkport businessmen, Enoch Cousens and Charles Perkins. Together, they purchased approximately 600 acres at Cape Arundel and Kennebunk Beach. They laid out lots, built roads, turned farmhouses into boardinghouses, and constructed the first hotel: the Ocean Bluff. In time, the name of the company changed to the Kennebunkport Sea Shore Company. Unfortunately, the stock market panic of 1873 slowed development and almost destroyed all plans for a summer resort. The Sea Shore Company began marketing lots at Kennebunk Beach in 1882. By the 1880s, economic conditions had improved, and with the opening of the Boston & Maine Railroad station at Kennebunk Lower Village in 1883, a building boom began. The heyday of the summer visitor in the Kennebunks had begun. Kennebunkport would eventually rank with Bar Harbor, Maine, and Newport, Rhode Island, as a resort town, although no million dollar marble estates would be built there. Kennebunkport was for the wealthy working class—doctors, lawyers, and professors—as well as single women living on the threads of old family fortunes. The area also drew artists, writers, and actors, and would have its own playhouse and opera company in time.

Visitors were drawn to the town's old homes and history, along with its sandy beaches, rocky coastline, and, of course, the ocean. Some visitors built huge, rambling cottages in the popular shingle style, which incorporated shingles that were left unstained and naturally weathered in the elements, rock foundations, vast rooflines, and wide porches. These huge cottages would only be used three months out of the year. If one could not afford to build a cottage in the Kennebunks, accommodations could also be found in the area's many hotels, or in the numerous guesthouses that owners opened in their private homes to take advantage of the tourist trade. These guest homes offered cheaper rates and a more personal atmosphere. In August 1899, the *Wave*, Kennebunk's summer newspaper, reported, "Several Cottagers announced that they will bring horseless carriages with them next season." The arrival of the automobile signaled the end of the large summer resort hotels.

Americans began taking to the roads, traveling by day, staying at night in roadside cabins, and eating at diners. Roadside culture developed quickly with campgrounds, motor courts, cabins, diners, and gas stations. Businesses owners attracted automobilists by creating unique and colorful signs and theme motor courts. Cabins in the shape of tepees, miniature log cabins, or European villages, for example, began to dominate the newly constructed highways across the country. Hotels in the Kennebunks tried to adapt by adding garages and car services. Both World War I and the Depression cut into business, as fewer Americans traveled. When World War II began, many of the large hotels and supporting businesses shut down for the duration. Afterward, patrons failed to return to these hotels; whole summers at large resorts were replaced with the two-week vacation. By the 1960s, slow business, new fire regulations, and rising land values resulted in hotel owners demolishing their hotels and selling the land off in lots. Also, many hotels not intentionally destroyed by their owners fell victim to fire.

Road conditions were a huge problem for the early motorist. In the 1920s, Maine began a road-building project that replaced the old Route 1 with a new, three-part concrete highway from Kittery to Bar Harbor. The old path from Kennebunk to Biddeford was a twisted, narrow

road, with several buildings located close to its edge. Many small businesses and farms lined the old Post Road, and property owners were in favor of widening and straightening the existing road rather than constructing a new route. In the end, the state prevailed, and a new road was laid out. Without the traffic from motorists, the businesses and farms along the old road closed. Some of the businesses that opened when the new highway was completed in 1928 are featured in chapter 2. The new road was a success, as were the new businesses, and in September 1931, the *Kennebunk Star* reported: "The overnight Camps along the state highway in York county have done a prosperous business this summer. Some of the proprietors report business ahead of 1930. It is understood that as a result of the increase in patronage some of the camp owners are contemplating building new camps before the opening of the season in 1932."

The popularity of roadside cabins and restaurants waned faster than that of the seaside resorts. New automobile technology created faster and safer cars that could travel on less gas and needed fewer repairs, and as such, the need for roadside cabins declined. By the 1930s, Hollywood was making movies that depicted motels as being run-down and popular with criminals. During the 1940s, several business owners were raided frequently for renting cabins by the hour or running illegal gambling in back rooms. Finally, new highways like the Maine Turnpike, which opened in 1947, cut off old highways and changed the way Americans traveled. Modern hotels based on the designs of Holiday Inn and Howard Johnson attracted travelers with clean, safe rooms, and spelled the end of roadside motor courts. Some survive today, but most were lost to fire, road expansion, or neglect.

One of the interesting things I found during research was that the construction dates of many early homes in the Kennebunks had been pushed back by exactly 5 or 10 years. The Colonial Revival movement that began in 1876 was at its peak at the turn of the 20th century, and buyers were looking for older homes with a connection to the Revolutionary era. In order to sell, homeowners were not above pushing construction dates back or creating new histories for their homes. (For instance, various published sources have given different construction dates for Barnard's Tavern [shown on page 16], including 1761, 1776, and 1784.) Because of these inconsistencies, the reader may find I have given different dates than ones normally accepted. Each image has been thoroughly researched and carefully dated.

Unless otherwise noted, the 200 images in this volume are from my personal collection, 15 years in the making. Many of the images came from postcard negatives and were taken by Clarence Mead, who was a traveling photographer. Mead went from town to town photographing local landmarks and businesses, and he made the postcards to sell to local vendors.

One

KENNEBUNK

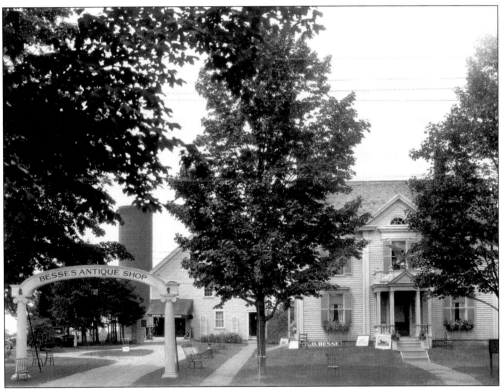

A. O. Besse's Antiques, pictured *c.* 1930, was built in Kennebunk *c.* 1880 for the Fairfield family. It was later bought by the water company to allow the construction of a standpipe, seen on the far left. Albert O. Besse operated the antique shop here from 1926 to 1940. In 1945, Besse died in Bridgeton at age 81. Later owners opened the home as a guesthouse called the Three Maple Inn for the large maple trees seen here. Today, Victorian Lighting is located on this site.

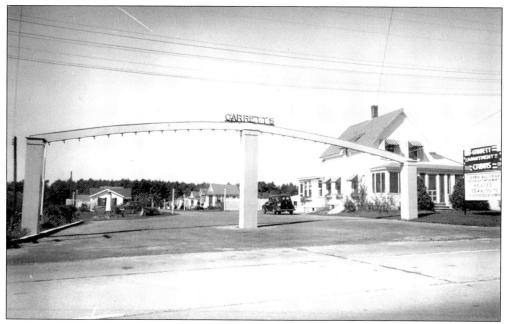

In October 1940, the *Kennebunk Star* reported: "Alfred Garrett is making an addition to his house on York Street which will provide a dining room 18 x 18 feet and a kitchen 10 x 23 feet. He is also building 3 cabins in the field at the rear of his house." Garrett expanded the complex until it appeared as it does in this postcard. The front arch, with its row of lights, must have been impressive when lit up at night. He sold the house to the Garry family in 1953.

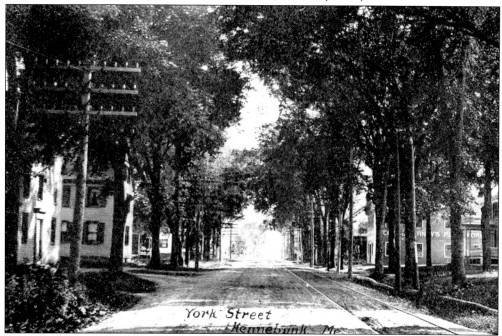

York Street is shown in this southward view toward Wells *c.* 1905. Varney's Plow Works appears on the right. Fred B. Tuck opened an antique shop on the site after he married Varney's daughter. Electric trolley line tracks are visible along the right side of the road.

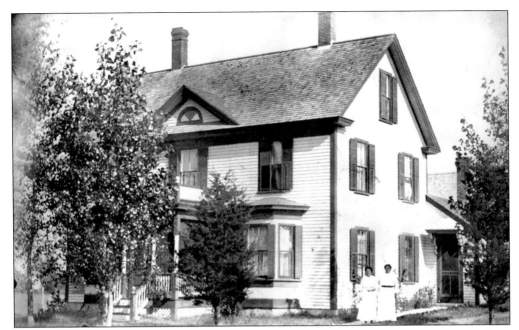

Pictured *c.* 1910, this home on the corner of York and Hall Streets once belonged to Woodbury Hall, who had been a stagecoach driver in the Kennebunks. Hall Street is named after him. The home was built or moved to this site after 1875. The women in this view may be members of the Penny family, who lived here in the early 20th century.

The Lafayette Elm was the second-largest elm in the state, at 131 feet tall and with a girth of 17 feet 3 inches. It died from Dutch elm disease and was taken down in the early 1970s. The tree was named for General Lafayette, who visited Kennebunk in 1817 and supposedly had lunch under the elm.

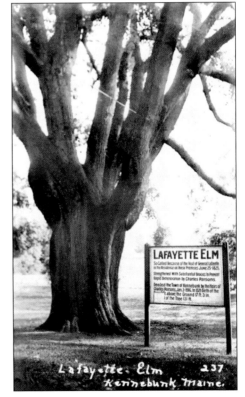

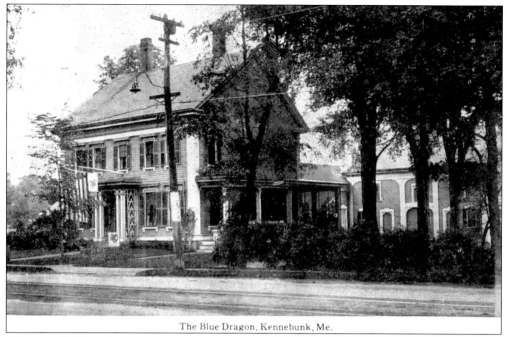

The Blue Dragon, Kennebunk, Me.

The Greenleaf Hotel was originally a private home built in 1806 by Samuel Low, who sold the unfinished building to Enoch Hardy the following year. Sometime before 1909 it was an inn called the Blue Dragon.

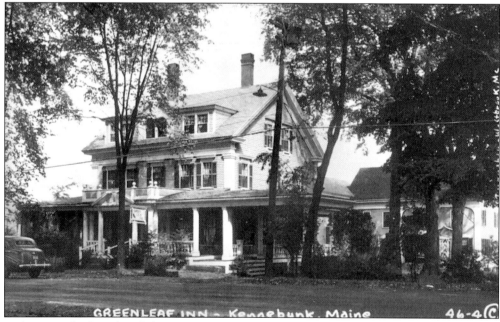

GREENLEAF INN – Kennebunk, Maine 46-4 C

Perley Greenleaf purchased the property in 1915 and opened the house to tourists in 1920. An article in the *Kennebunk Star* described the newly remodeled and enlarged hotel in glowing terms. At that time the staircase was replaced with a new one, the dining room was extended, and the piazzas and new bathrooms were added. New rooms were added on the third floor, and the elaborate dormer was constructed.

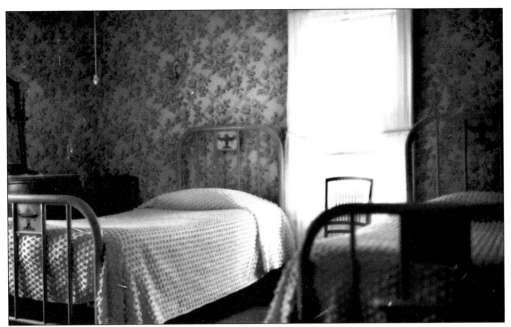

This interior view of the Greenleaf Hotel c. 1930 shows one of the bedrooms, with the infamous iron beds used in almost all hotels and guesthouses at that time. The building was converted to condominiums in 1977.

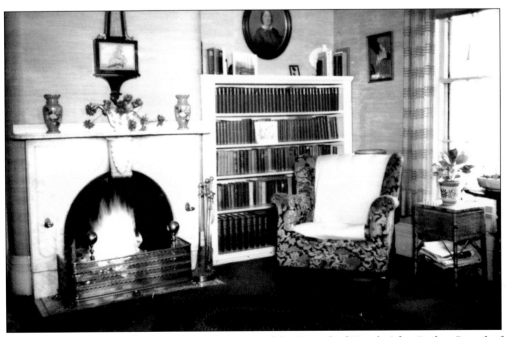

The parlor is shown in this c. 1930 interior view of the Greenleaf Hotel. After Perley Greenleaf died in 1937, his wife continued managing the hotel until 1945, when she sold it to Wallace Jack. In the 1960s, the place fell on hard times, was turned into apartments, and for many years was considered a flophouse. Eventually the barn was demolished to make space for more parking, the elms died, the porches were removed, and other decorative work vanished.

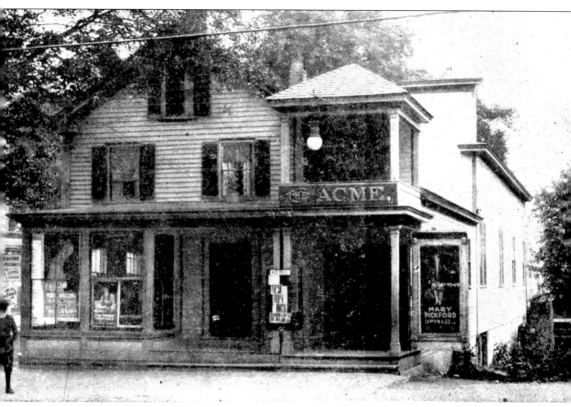

Acme Theatre, Bodowin's Block, Kennebunk, Me.

Seen here in 1919 is the newly rebuilt Anchor Theater, originally called the Acme Theater. In 1945 Wallace Reid sold the theater to Katherine Avery, who remodeled it. Inside, the lobby featured murals of historic Kennebunk scenes painted on acoustic tiles (ceiling tiles) by artist Frieda Weeks. Several of these survive in private collections and at the Brick Store Museum in Kennebunk. In 1950 Avery built the Kennebunk Drive-In on Portland Road. Designed by H. J. McKenny of the Theater Supply Company, Boston, the drive-in quickly became a popular summer destination for families. On Sundays church services were offered there! In 1980 dwindling business and increasing land values forced the drive-in to close. The Anchor Theater closed in 1960, and in 1961 Warren Bowdoin razed the front section and moved the rear section back to expand his drugstore.

FLEETWOOD, DANE STREET
KENNEBUNK, MAINE
W. H. SIMONDS, PROPRIETOR

The Fleetwood Hotel, shown here *c.* 1910, was located on the corner of Dane and Elm Streets. It was originally a double house built by Barnabas Palmer, and later was sold to Capt. George A. Webb. His granddaughter Caroline converted the home into a hotel in 1904 and ran it with her husband, W. A. Simonds.

The Littlefield & Rose Garage, on Portland Street in Kennebunk, is pictured here *c.* 1925. Today the building houses Melewha's Chinese restaurant. The Kennebunk Drive-In was built in 1950 in the field to the right of the building (the area next to the bus in this view).

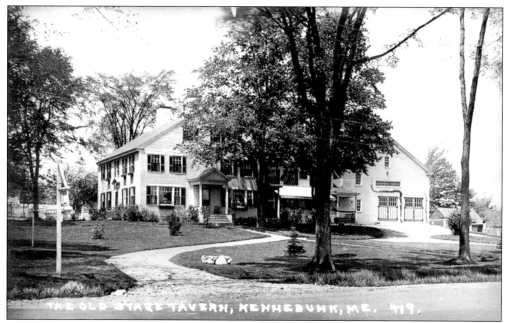

Barnard's Tavern is shown *c.* 1925. It was built in 1785 by Joseph Barnard, who was a post rider. Barnard's is a fine example of the Georgian-style architecture popular at the time of the American Revolution. Because of this, the building has often been misdated to 1776. It is one of the few buildings of that style to survive in the area. The Day family purchased the property in 1917 and opened it as a guesthouse called the Old Stage Tavern. The building was heavily damaged in a fire in 1975 and was threatened with demolition, until Bill Johnson stepped in and saved it.

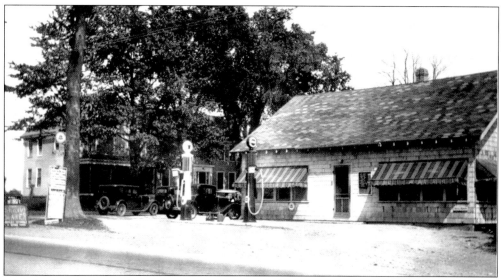

Wonder Brook Farm, pictured in 1930, was originally used as a dairy farm and supplied milk products to the Kennebunk area. Paul Noyes built the filling station and restaurant in 1926, and later Alva Smith operated the business. Shopper's Village occupies the original site today, but the restaurant was moved across the street and converted to a home. It still stands today and houses Courtney Cleaners. (Courtesy Kennebunk Free Library.)

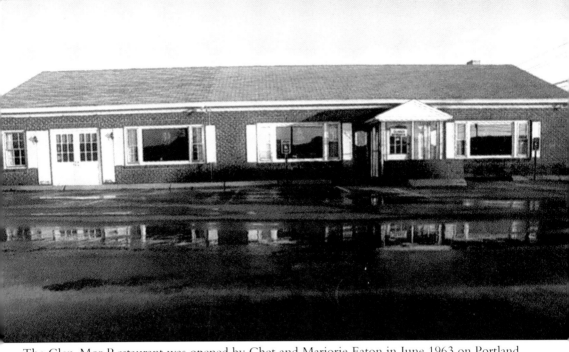

The Glen-Mor Restaurant was opened by Chet and Marjorie Eaton in June 1963 on Portland Street. The Eatons ran the restaurant for more than 20 years, and it became a popular dining place for local residents and tourists alike. Local organizations like the Rotary Club often met at the restaurant. The banquet room, added in 1965, doubled the restaurant's size, and was the favorite place in town for wedding receptions and private parties. Every Christmas, the Eatons gave away free meals. After Chet died, Marjorie continued to operate the restaurant, until she retired in 1982. My grandmother Gertrude Barrett went to work for the Eatons shortly after the restaurant opened. She would start work at four in the morning, baking all the pies, cakes, and cookies, and then go out front and wait on the counter during lunch. After Marjorie and my grandmother retired, the Glen-Mor was never the same. An arson fire destroyed this landmark on December 14, 1997.

Seen here *c.* 1915, William Bartlett's home and sawmill were located on Route 1, next to the Kennebunk River. Built as a traditional New England Cape, the home was remodeled by Bartlett in the 1890s to become a spectacular three-story Colonial Revival mansion, with a gambrel roof, wrap-around porch, dormers, and a bay window. The building to the far right was Bartlett's store, and across the street was his sawmill. Bartlett, a true lumber baron, built cottages behind his home *c.* 1920 and opened them to tourists.

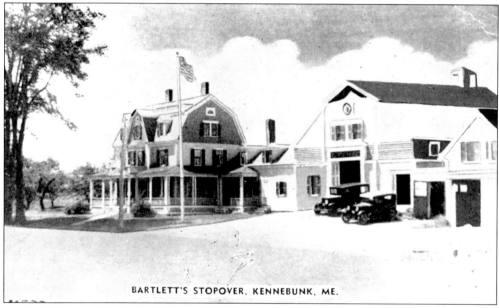

BARTLETT'S STOPOVER, KENNEBUNK, ME.

Bartlett's Stopover is pictured here *c.* 1925. The back of the card reads, "Modern Rooms and Cabins Heated, Hot and Cold water $1.00 per person." The barn, store, and ell of the home were destroyed in a 1927 fire. Bartlett quickly rebuilt the buildings exactly as they had been before the fire. By 1980, the sawmill, barn, and store had collapsed, and the wooden clock that once graced the front of the barn had been stolen. The house was eventually deemed unsafe and burned for fire practice.

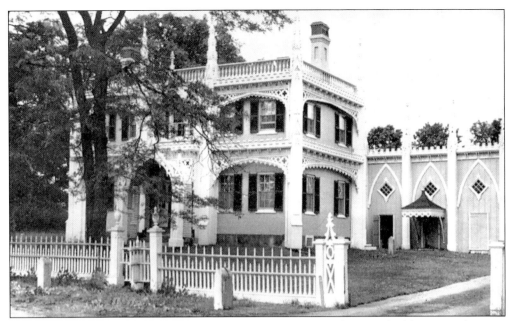

The Wedding Cake House, shown *c.* 1910, is one of the most photographed homes in the state. In answer to repeated questions about the origin of the famous house, a story developed equating the decorative trim to a wedding cake. Supposedly, a sea captain was suddenly called away from his wedding to depart on his ship, thereby depriving the bride of a wedding cake. To make up for this loss, the returning sea captain built the home for her. Actually, the whole design was the result of a barn fire in 1852. George Bourne, the owner, rebuilt the barn and carriage shed in the then-popular Gothic style. Around 1855, he designed and carved the trim that covers the main house, a late-Federal structure built in 1826.

This view of Summer Street looks toward town *c.* 1910.

The Landing Store originally stood on the right corner of Durrel's Bridge Road and was known as the Samuel Lord store before 1900. Mary Marshall bought it in 1913 and moved the store to its present location. At this time, it was known as the Way Side Cash Grocery. Jesse Ham, who had moved to Kennebunk in 1900, rented the building in 1920. Pictured here c. 1920, Ham sold groceries, candy, and ice cream and lived in the back of the store. On September 4, 1925, the building was destroyed by fire. Afterward, Ham purchased the building and rebuilt it as it stands today. (Courtesy Brick Store Museum.)

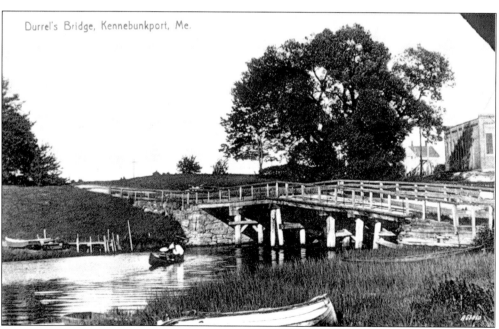

Durrel's Bridge over the Kennebunk River, seen c. 1915, was a drawbridge that opened to allow the ships built at the Landing to pass. The powerhouse on the far right was built c. 1906 to provide power for the electric trolleys. It burned in 1926.

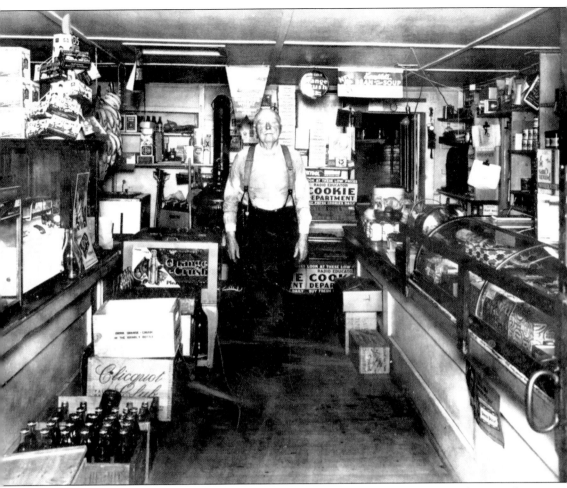

Mr. Vanderzee, called Mr. Z by patrons, bought Jesse Ham's former store in 1940 and operated a grocery there with his daughter until 1954. They lived across the road, at 156 Summer Street. Ruth Goodrich owned the store from the mid-1950s to the mid-1960s and operated it seasonally. The store was open from 8:00 in the morning until 8:00 at night, seven days a week. By 1959, it was known as the Landing Store. Goodrich sold the store when she retired, but held the mortgage and lived on the payments. The store has had many owners over the years, including Kenneth Atherton, Paul Bedard, the Turkingtons, the Conkels, and the Fortes. (Courtesy Morey Highbarger.)

The Perkins Farm in West Kennebunk, pictured c. 1920, was built c. 1785, and Oliver Perkins acquired it in 1826. His wife, Sarah Littlefield, was the daughter of the builder. Perkins opened the home as a tavern c. 1846 because of the busy road in front, a direct route to the county courthouse in Alfred. In 1940 the home was sold to the Howard family, who owned it for more than 50 years. The home was once known for its perfect appearance, neat front lawn, and tall, stately elm trees. Over the years, however, the farm fell into disrepair, was abandoned, and the barn collapsed. An out-of-town buyer eventually purchased the farm and land for a housing development. The historic home was gutted, and the doors, windows, woodwork, mantels, and the original staircase were all destroyed. (Courtesy Kathy Ostrander.)

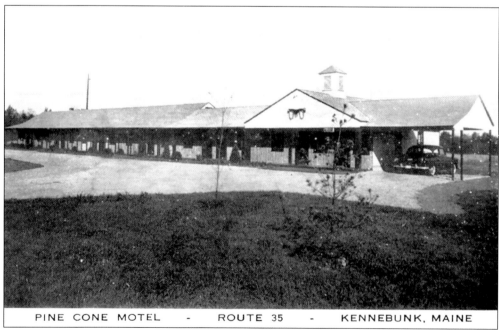

PINE CONE MOTEL - ROUTE 35 - KENNEBUNK, MAINE

The Pine Cone Motel, built following the opening of the Maine Turnpike in 1947, is located on Route 35, after the southbound entrance to the turnpike.

Two

NORTH KENNEBUNKPORT

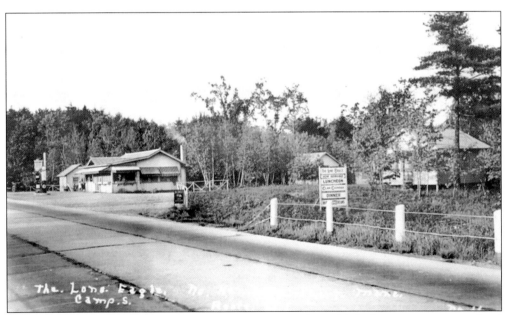

When the new highway from the Kennebunk River to the Biddeford overpass was completed in 1928, it opened five miles of woods to new development. Several motor courts, restaurants, and stores opened along the new road, including the Lone Eagle Restaurant and Campground. Daniel T. Hilyard owned the business in the 1950s, and in 1960 Leonard and Nora Nallet leased the restaurant. In 1965 they reopened it as a pancake house. Wiers Motors opened on the site in 1967.

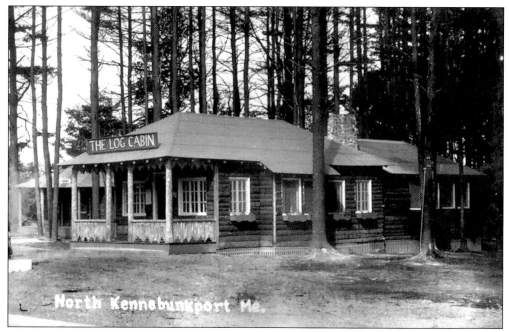

In 1932, the Log Cabin Motor Court was opened by Edward and Esther Tibbets, who had purchased the land on the new highway from William Bartlett. Located where USA Antiques is today, the cottages were designed to look like small log cabins and were built under towering pine trees. Each one was named for a state. North Kennebunkport became Arundel in 1956.

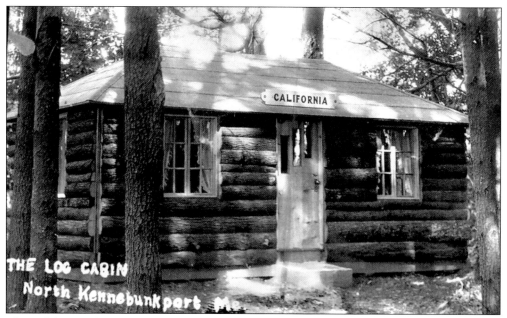

The California cabin is pictured here. After he purchased the complex in 1958, William Silliker opened a lobster pound and had plans to expand the business with a restaurant and banquet hall. A fire ended those plans. After the motel closed, most of the cabins were sold and removed from the site.

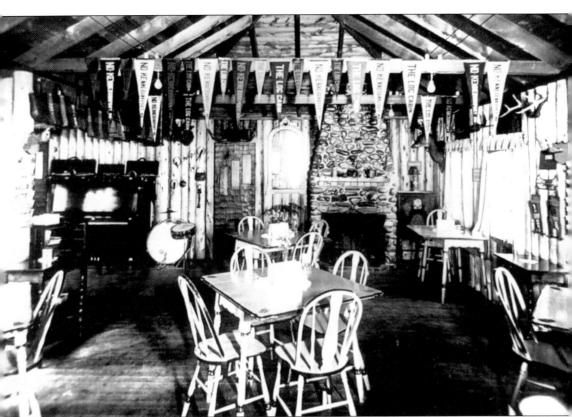

The Log Cabin Ballroom featured dances every Saturday night, with music provided by local bands. It was a popular place for locals to dance at, although every now and then things got a little rough. It was said that a lot of romances started there, and quite a few ended there too. Some of the bands that played at the ballroom were Johnny Trull from Old Orchard, Robert Percival and his band from Portland, and Babe Sutherland and her all-girl band from Old Orchard. In 1958 William Silliker of Sanford bought the motor court and ballroom. He sponsored a club called the Bon Temps, which required semi-formal dress and restricted admission to ease the reputation the place had for rowdy times. In January 1964, the ballroom burned down in a huge fire that was fed by 30 years of built-up floor wax. Eighty-five firemen fought the blaze, while flames leapt 50 feet into the air. The cabins were saved, but the ballroom was lost. It was not rebuilt.

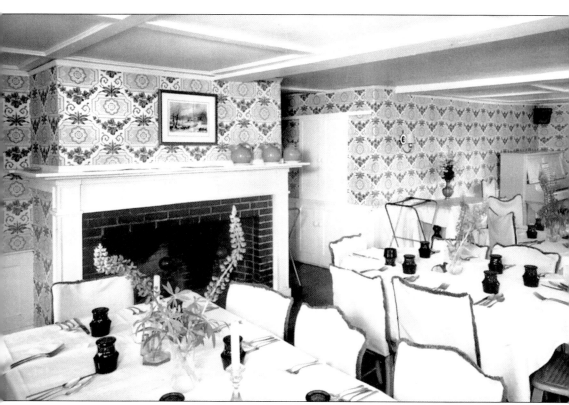

The Forefather's Inn, shown c. 1960, was located on Log Cabin Road and was originally a small 18th-century home and farm. Purchased by B. S. Thompson in 1895, the inn was opened by 1907 as the Red, White, and Blue House, a tavern that sailors would get to by taking the trolley from Dock Square. Entrepreneur Fred B. Tuck purchased the property in 1915, and by 1917 he had changed the name to Forefather's Spring House, a name he himself had created for the natural spring on the property. Tuck was an inventive businessman and was known as the first antique dealer in Maine. He used tourists' interest in Colonial American history to his advantage, and most likely fabricated the story about the old house having been a stagecoach stop (for which no documentation has been found). Tuck knew how to create the environment that attracted shoppers, even if it meant stretching the truth. Bertha Lux purchased the property in 1921 and remodeled it, adding electricity and running water. Later owners operated a restaurant that featured live music by blues, jazz, and rock bands. In 1979, an arson fire destroyed the oldest section of the building. The restaurant was rebuilt and later reopened, but has been closed for several years now.

Forefather's Inn

LOG CABIN ROAD, ARUNDEL, MAINE

Tel. 967-8971

Turn left off Route One on Log Cabin Road, Arundel, Me.
1 mile from Kennebunkport Playhouse
"Where the Stars Meet"

COCKTAILS — DANCING — ENTERTAINMENT
**with DICK ANASTASOFF QUARTET and the INN BOYS
3 Floor Shows Nightly with Continuous Dancing
and entertainment 9 p.m. - 1 a.m. Monday thru Saturday**

"HAPPY HOUR" Daily 4 p.m. - 7 p.m.
Free Hors D'Oeuvres — Entertainment

LUNCHEONS — DINNERS Served Daily
**Dining Room Entertainment 7 p.m. - 9 p.m.
MIDNIGHT BREAKFAST 1 a.m. - 2 p.m.**

INTERNATIONAL BUFFET every Saturday Night
7:30 - 9:30 ALL YOU CAN EAT $3.95
DIFFERENT MENU EACH WEEK

SPECIAL SATURDAY FEATURE
MUSICIANS JAM SESSION 1 p.m. - 4 p.m.

COME ONE! COME ALL!

We Honor Diners Club — American Express — Carte Blanche

This advertisement for the Forefather's Inn appeared in a 1967 tourist guide. Joseph and Celia Laplante bought the restaurant in 1950, and in 1968 George Wiltshire acquired the property.

27

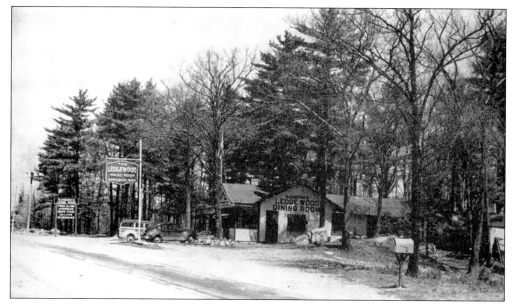

Shown here *c.* 1935, Sanborn's Ledgewood Dining Room on Route 1 was opened by Pearl Sanborn by 1929. Sanborn, a native of Newtonville, Massachusetts, sold the restaurant to Richard and Betty Jane Moran in 1946.

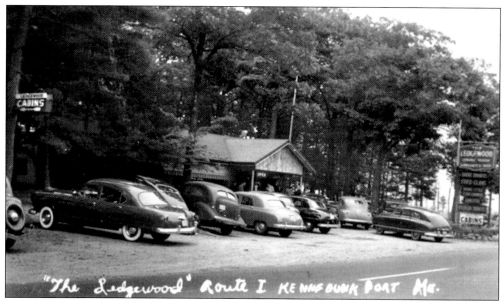

This *c.* 1950 photograph of the Ledgewood shows that the restaurant has been painted dark brown and cabins have been added. The Ledgewood had several owners after the Morans and remained opened into the early 1970s. It still stands today, although in derelict condition, having been abandoned since the mid-1970s.

Three

MOTHER'S BEACH

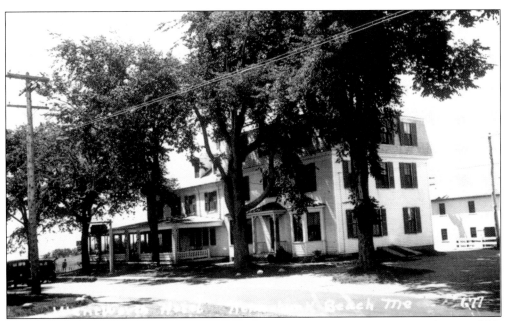

The Wentworth Hotel on Sea Road is pictured here *c.* 1935. Owen Wentworth opened his home to tourists *c.* 1860, and he is credited with being the first to do so after the Gooch family. Originally called the Beach House, it was later renamed the Wentworth Hotel. Mr. Wentworth was well liked in the community, and he encouraged others to go into the hotel business. To that end, he loaned money for new hotels and also built and sold his own hotels and cottages.

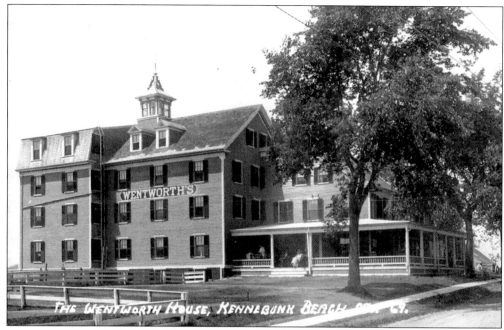

Owen Wentworth made several additions to his hotel—in 1869, 1875, and 1895—until it appeared as seen in this postcard. After Wentworth died in 1901, the hotel remained in the family until 1944, when it was purchased by Wallace Jack. It was demolished for condominiums in 1982.

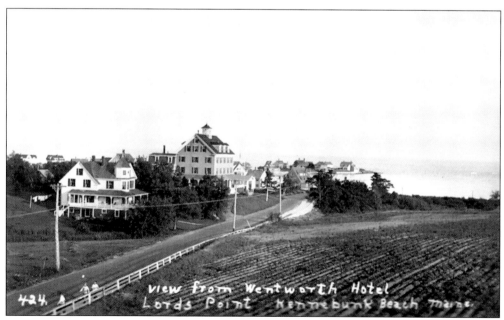

This sweeping view of Lord's Point and the cove was taken from the Wentworth House. The Eagle Rock Hotel, with the cupola, is second from the left.

The Knoll was a summer restaurant located on Sea Road at the intersection of Route 9, opposite Bennet's Deli. It was advertised in the summer newspaper *High Tide* in 1937. No further information has been found, and the building no longer stands at that location.

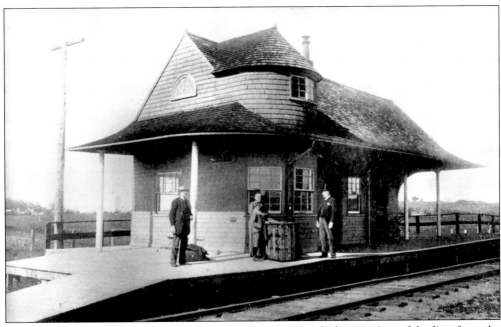

The Kennebunk Beach Station was built in 1883, along with the opening of the line from the Boston & Maine Railroad station in Kennebunk to Lower Village. The Kennebunk Beach Station became the hub of the beach, and also served as the area post office. After the line closed in 1926, the station was converted to a summer cottage and was moved to Great Hill, where it still stands.

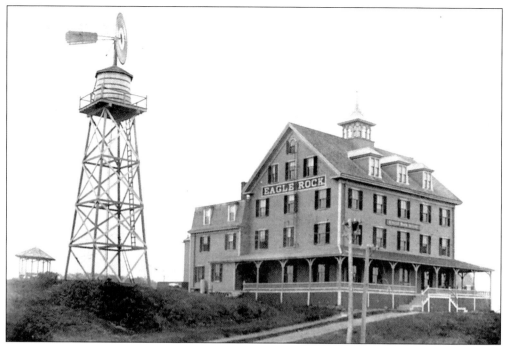

The Eagle Rock Hotel was located on the Sea Road, just below the Wentworth Hotel, and was completed for Owen Wentworth in 1886. Again, as with other hotels in the area, the Eagle Rock was located on a rise of land, giving patrons cool breezes and grand views. Later, a Mr. Wellman took over the running of the hotel. He also owned a hotel in San Francisco that was destroyed in the 1906 earthquake.

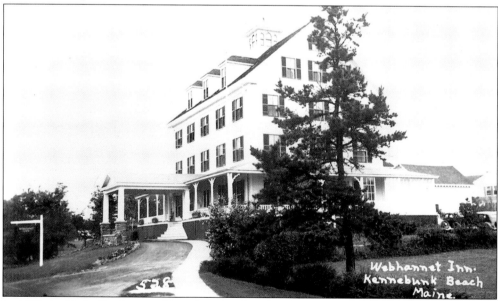

In 1927 the Eagle Rock was sold to A. J. Smith, who changed the name to the Webhannet. In 1964 Jon Milligan and his wife, Elizabeth, purchased the hotel. Because of the high costs to meet local and state fire regulations, the top three and a half floors were removed and the first floor was converted into a cottage.

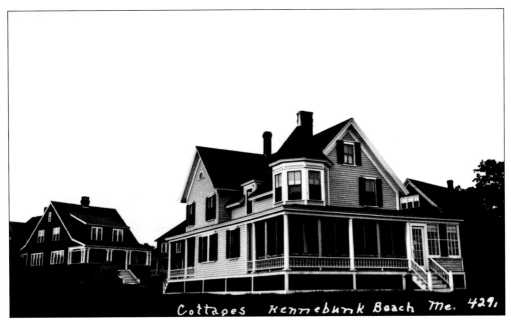

Bay Cottage, seen here *c.* 1935 after improvements (see page 38 for an earlier view), was built by Owen Wentworth as a rental property. It still stands, though greatly altered.

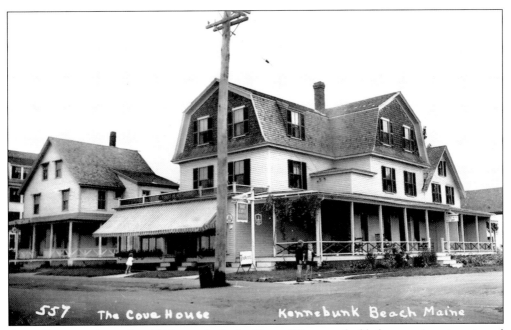

Cove Cottage, pictured *c.* 1910, was built for Owen Wentworth, likely as an investment, and was opened by 1882. After Wentworth sold the business, it served as a guesthouse, restaurant, and store. In 1905 the original building was moved back, and the front section with the gambrel roof was built. The original building can be seen at the back of the front section, where it became a rear ell. Now converted to condominiums, it still stands today on the corner of Railroad and Beach Avenues.

33

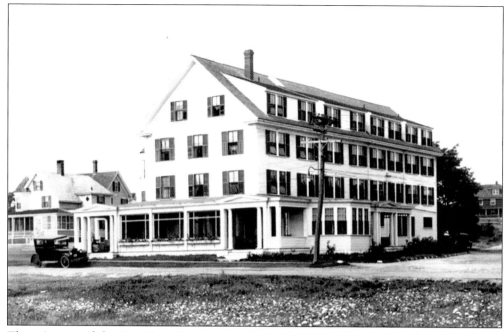

These images of the Sea View House were taken after the 1919 renovation. The Sea View was built in 1882 for Capt. Joseph Hubbard and Henry Heckman. They bought the land from financier Owen Wentworth. In 1884, the two men dissolved their partnership and Hubbard bought out Heckman. Hubbard's son Sewall married Elvira Peabody, the daughter of Capt. Frank and Georgina Gooch Peabody. It was Elvira who ran the hotel after her marriage, continuing to do so until her death on December 16, 1938. Her obituary in the *Kennebunk Star* described Elvira as "a woman of great strength of character and beauty of temperament. Serene, steadfast, true, a loving wife and mother, a kind neighbor, and generous hostess, she was for nearly two generations a central figure in the life of Kennebunk Beach and its environs."

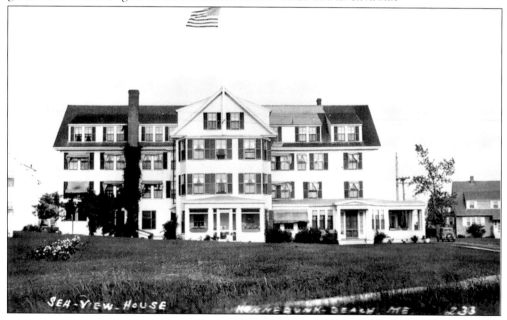

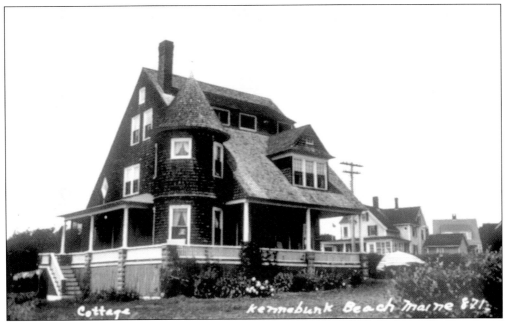

The Elvira Hubbard House on Beach Avenue, pictured *c.* 1935, was built in 1908 and was first used as an annex for the Sea View House. Later, Elvira made her home here. The Sea View remained in the Hubbard family until 1950, when it was sold to Eben Moon, who then sold it to the Merrow family in 1955. The hotel was razed in 1962, another victim of the declining tourist industry.

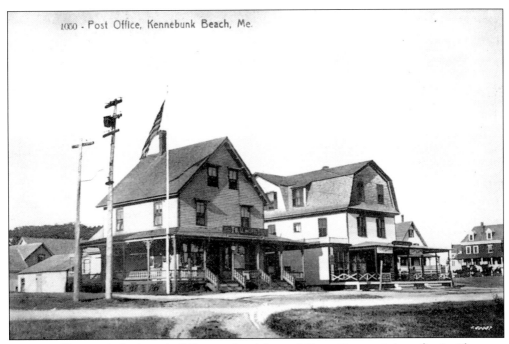

B. U. Huff's store is the large building on the right, and Cove Cottage is just after it. The store was later converted into a summer cottage, which still stands today.

Shown here *c.* 1935, Knowles Cottage was built in 1927–1928 for James T. Knowles. Knowles was a flour broker from West Newton, Massachusetts. When built, the $10,000 cottage had 12 rooms, 4 baths, fireplaces, and a 2-car garage. It was constructed by contractor/builder Randall J. Grant, who played an important role in the development of Kennebunk Beach. For 45 years, Grant was the builder whom property owners trusted. His work included the Charles Goodnow House, 34 Summer Street; the Llewelleyn Parsons House, Crescent Surf (now Parsons Beach); St. Martha's Church, Kennebunkport; Cousens School, Kennebunk; and the Charles Arnold Jr. Cottage, Lord's Point.

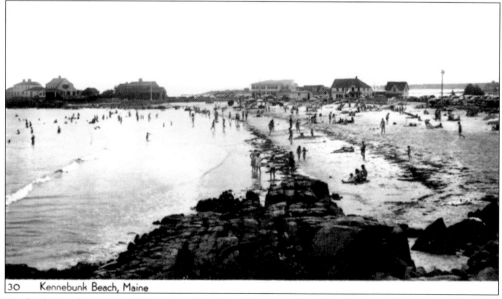

Mother's Beach, seen *c.* 1945, was originally called Boothby's Beach, named after an early settler who lived nearby. In the distance can be seen the Eureka Bath House on the left and the Dipsy Bath House to the right. Lord's Point is to the left.

Bryon's Point, pictured c. 1930, is located between Mother's Beach and Middle Beach. The winter of 1927–1928 was a busy time at Kennebunk Beach, as an estimated $100,000 was spent in new construction and remodeling. Several older cottages were razed and replaced with homes that could be used year-round, like the one above, built in 1927. Builder Randall Grant and his sons did most of that work. Grant was born in West Kennebunk; when he was 14, he was sent to Everett, Massachusetts, to learn the carpentry trade with his uncle. In addition to new construction, Grant updated many of the older homes in the area. He was later joined by his sons Randall and Harold, who continued the business after their father passed away in January 1938.

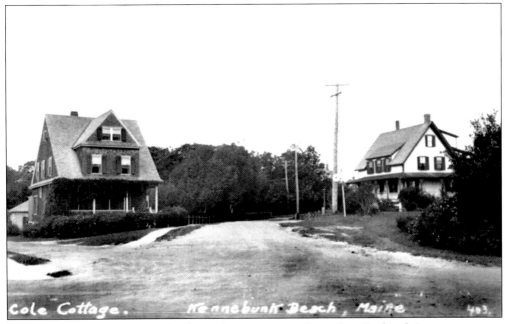

Seen here c. 1930, these Kennebunk Beach cottages were located on Railroad Avenue.

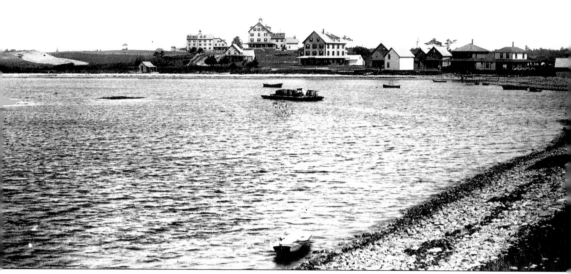

This view of the Cove was taken from Lord's Point *c.* 1895. In the upper row, the Wentworth House is at the far left and the Eagle Rock Hotel is to the right of it. On the shorefront below them, Bay Cottage is at the left end and the Sea View House is second from the left. Of these buildings, only Bay Cottage remains today.

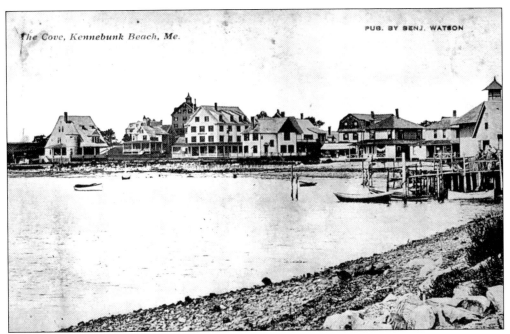

The Cove appears in this *c.* 1910 view from Lord's Point. The buildings are, from left to right, the Elvira Hubbard House (with the round tower), Bay Cottage, the Sea View House, Huff's (hidden), and the Cove House.

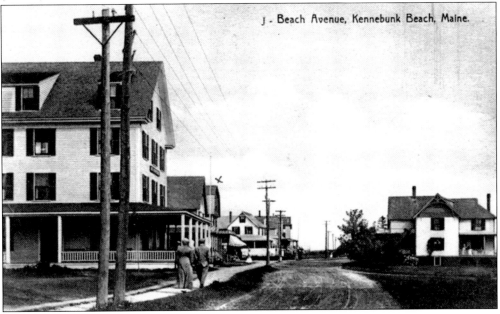

In this *c.* 1915 photograph of Beach Ave., the Sea View House is seen on the left before its 1919 renovations. Mother's Beach is straight ahead. A brochure of the same vintage as the card above offers this information: "Kennebunk Beach is between Boston and Portland. Three express trains make the trip between Boston and Kennebunk in two hours and a half. The express which leaves New York at half past seven each evening arrives in Kennebunk around five o'clock the next morning."

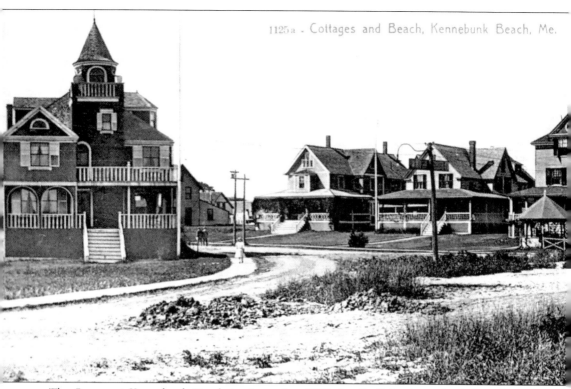

The Square at Kennebunk Beach is pictured *c.* 1905. Lord's Point is to the left, and on the far right is the Atlantic Hotel, just visible above the cottages. On the far left is the cottage once known as the "Lighthouse," which today houses the offices of the Kennebunk Beach Improvement Association. The cottage that stands alone at center right was the summer home

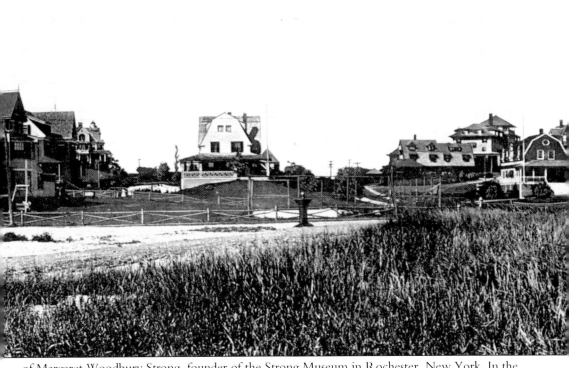

of Margaret Woodbury Strong, founder of the Strong Museum in Rochester, New York. In the 1960s, Strong surrounded her yard with old bathtubs, probably from one of the beach hotels. These were half-buried in the ground and made for an interesting sight.

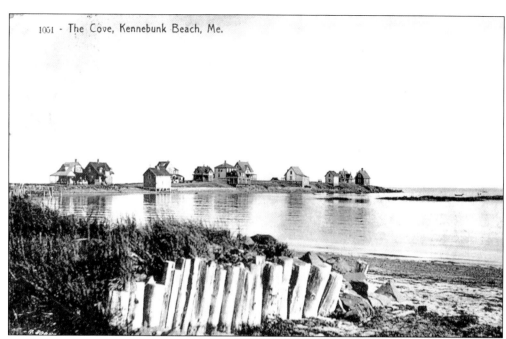

1051 - The Cove, Kennebunk Beach, Me.

Hartley Lord was a well-to-do businessman who owned a home on Summer Street. In 1872 he purchased the point of land known as Two Acres. There he had 15 lots laid out, which Lord later sold to family and friends. Some of the buyers were notable Kennebunk residents who moved to the beach each summer to escape the heat and noise in town. Today the area is known as Lord's Point.

Grey Gable Cottage, seen here *c.* 1935, was built around 1905 and was owned by Charles Gleason of Haverhill, Massachusetts.

42

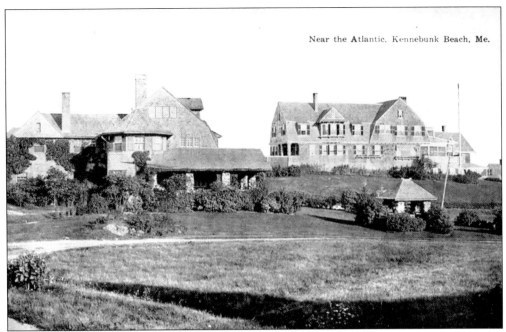

The Arnold Cottage appears on the right in this *c.* 1910 view. Named Hill Crest, it stands on a high ridge looking down on Mother's Beach. Charles W. Arnold built this large, 27-room summer cottage in 1901 on the former site of the Ridgewood Hotel, which burned down in 1898. Other cottages have been built around Hill Crest since its construction, making it almost impossible to see from the beach today. The cottage on the left is Gray Gable Cottage.

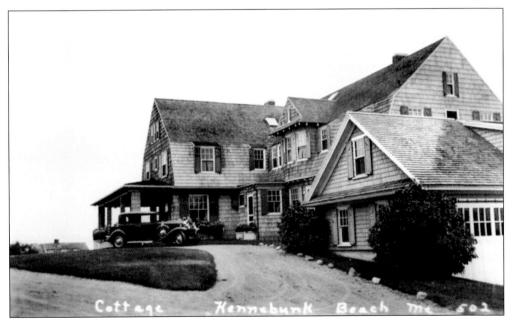

Several changes to the Hill Crest Cottage are evident in this *c.* 1925 photograph—the garage addition is one of them. Arnold loved the beach so much he gave each of his children a cottage nearby.

43

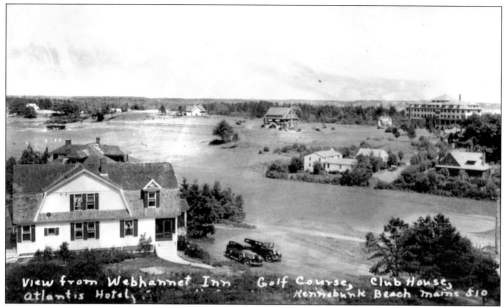

View from Webhannet Inn. Golf Course, Club House,
Atlantis Hotel. Kennebunk Beach Maine 510

Seen above is the Webhannet Golf Course *c.* 1930. Established about 1895, it started out as a three-hole course and was later expanded to nine holes. After the Atlantis Hotel was built in 1902, the course was expanded again. The clubhouse is in the upper middle, and to the right is the Atlantis Hotel. The building in the center of the image was writer Kenneth Roberts's studio. It was built with lumber salvaged from the barn seen in the center of the photograph below. The view below shows the golf course *c.* 1915. The Eagle Rock Hotel is the last building on the right.

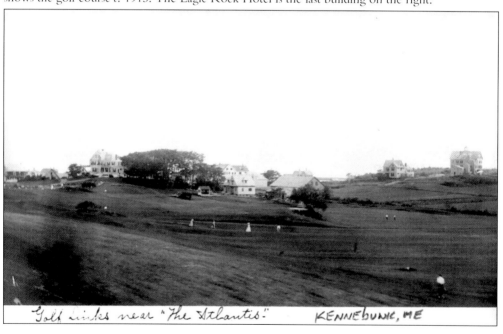

Golf Links near "The Atlantis." KENNEBUNK, ME

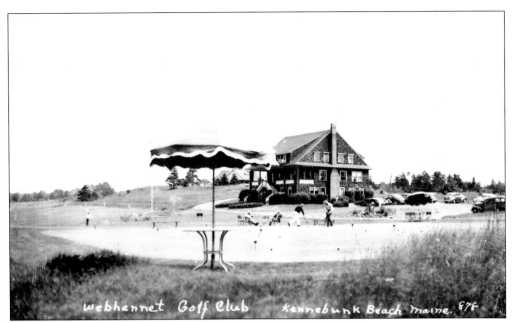

The Webhannet Golf Course clubhouse, shown c. 1935, was built in 1910.

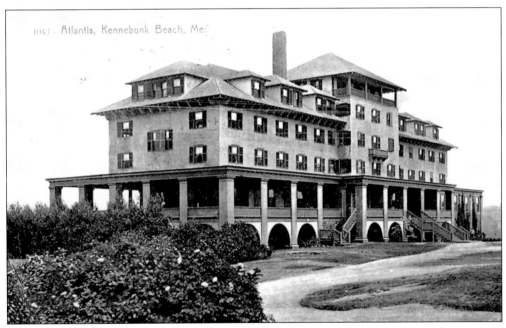

The Atlantis Hotel, pictured c. 1915, was built in 1902 in the Mission style. Its design was a departure from the early boxy hotels built at the beach. The Atlantis offered all the modern amenities available at that time. Beautifully situated on a high rise overlooking the Atlantic coastline, the hotel enabled guests to see all the way to Nubble Light in Cape Neddick, past Mount Agamenticus in York, and to the White Mountains 75 miles away on a clear day. The Merrow family purchased the hotel in 1959 and ran it until 1968, when dwindling business forced them to close. It was razed soon after.

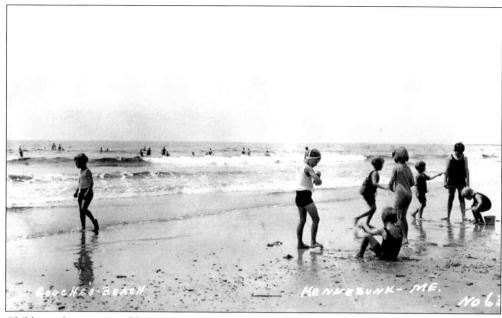

Children play on Gooch's Beach *c.* 1940. This card, mailed in May 1942, reads: "K. Beach, Maine—Thurs. a.m.—Dear Jim & Gil was at the door when I got home Sat. Very cold yesterday & day before & wind howls, as usual. H & B came last night after 10. Sun out for a change. The Lilacs are grand all around here. Expect to be home Sun. noon. Hotel burned Sun. night near here (set). Moving to big house today." The hotel that burned was the Granite State House.

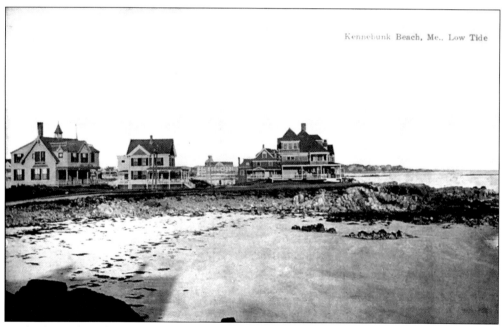

Mother's Beach is photographed at low tide *c.* 1910. It became known as Mother's Beach because its surf was gentler than that found at Gooch's Beach.

Four

GOOCH'S BEACH

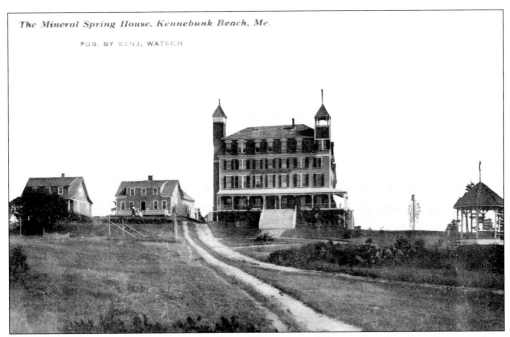

The Mineral Spring House, Kennebunk Beach, Me.

PUB. BY BENJ. WATSON

In 1887, William Paul built the Oak Grove Hotel on a hill on Boothby Road. It was later renamed the Mineral Spring House, after the spring located on the property. Although it was set back from the ocean, the hotel offered spectacular views because of its high location. It had a generator that powered electric lights, and the lights from the cupola could be seen all the way to Portland and as far down as York. Loring Edgecomb owned the hotel when it burned in 1916. It was not rebuilt.

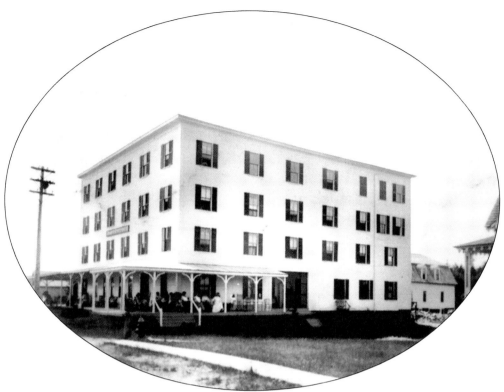

The Granite State House, shown here c. 1905, was built by Owen Wentworth in 1879, and then was sold to Alvin Stuart, whose wife, Ava, operated it for many years. Stuart made at least three additions to the original hotel between 1883 and 1900.

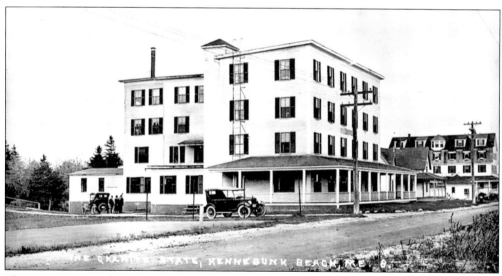

This c. 1915 view of the Granite State House looks toward the new Bass Rock Hotel. In 1914, the hotel was sold to John Curtis, who owned the Narragansett just down the road. When the Granite State House burned in May 1942, it was owned by Elizabeth Rankin. The fire was believed to have been set intentionally.

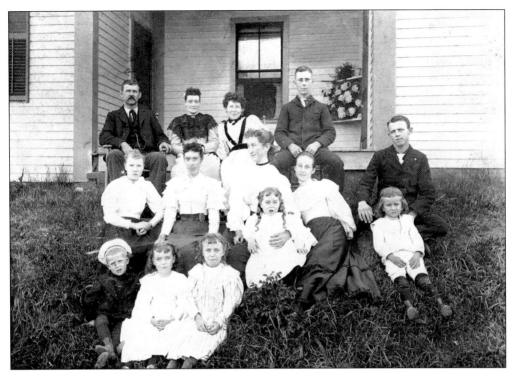

Members of the Gooch family are pictured at an unidentified hotel. William L. and Mabel Gooch, who owned the Sagamore Hotel, appear in the top row on the left. Otis Gooch is the last person on the right in the same row.

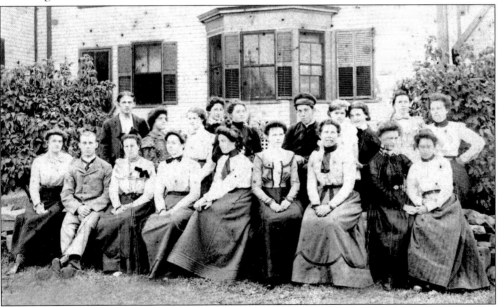

Hotel staff from an unidentified Kennebunk Beach hotel pose for a photograph. Otis E. Gooch, second from the left in the front row, was born in 1880, the son of William and Mabel Gooch, who built the Sagamore Hotel. Otis, who had been active in the local volunteer fire department for many years, died on May 20, 1964, at the age of 84.

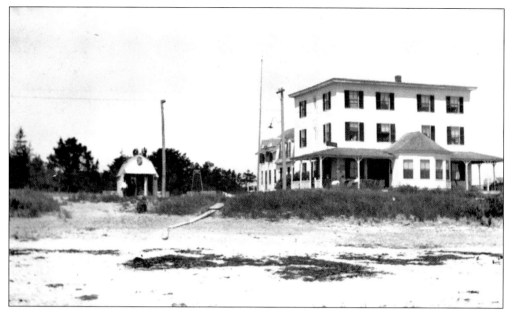

The Bass Rock Hotel is seen here *c.* 1900. On May 16, 1884, the *Eastern Star* reported, "Joseph Wells has bought the 'Sherburne Meeting House' so called near Government Wharf, of the Kennebunkport Sea Shore Company and proposes to take it down and move it across the river to be rebuilt and used as a summer boarding house." That house was the Bass Rock Hotel, located on Middle Beach near Boothby Road and the Granite State House.

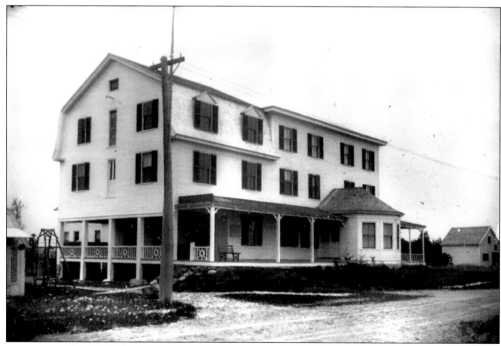

In 1905 Wells added the section on the left to the hotel. On Labor Day 1906, the Bass Rock Hotel burned to the ground.

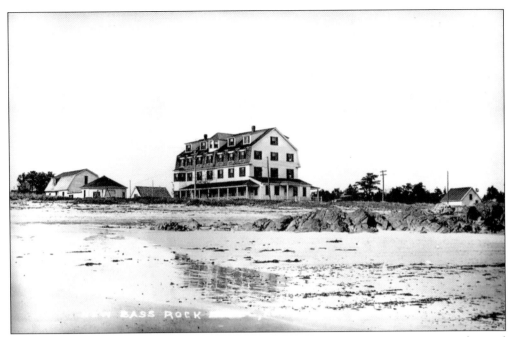

After the fire destroyed the Bass Rock Hotel, Wells and his sons built the new Bass Rock Hotel by themselves, completing it in time for the 1907 season. Wells continued to operate the hotel until his death, when his son Roy assumed control. Henry Walsh bought the hotel in 1923, and his son John later ran it until it was demolished in 1962.

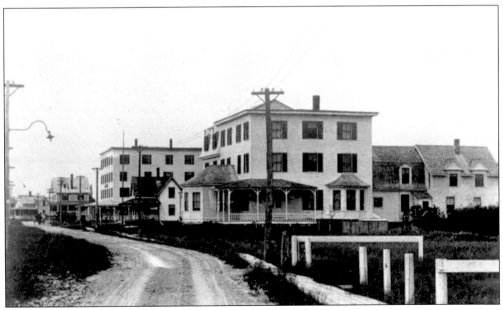

This c. 1905 view looks south past Gooch's Beach. The first hotel on the right is the Bass Rock, and the next hotel up the road is the Granite State House. The small cottage between them was built in 1883 for Alonzo Messer and still stands today. Beyond the Granite State House is the cottage that would become the Sundial.

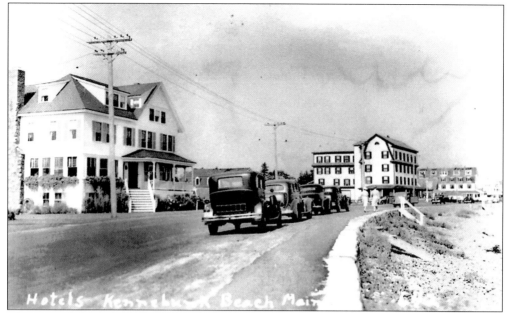

Looking toward Gooch's Beach, this view was taken c. 1930. The Sundial appears on the far left. To the right of it, further up the road, is the Granite State House, and just visible at far right is the new Bass Rock Hotel.

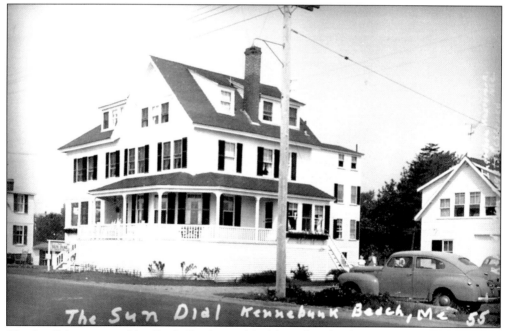

The Sundial was owned by Bessie Bartlett and had been her family's summer home. Designed by local architect William Barry, it was built before 1900. The large addition on the left was constructed in 1930. Bartlett died in December 1942 and left the property to Archie Clark. It is now called the Beach House.

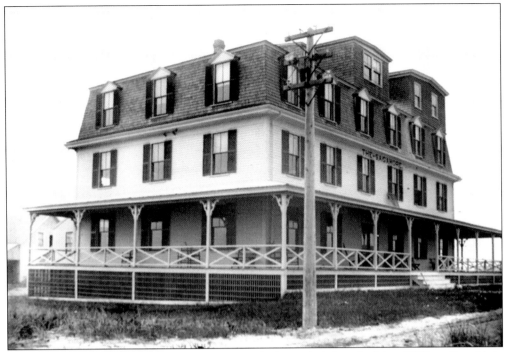

The Sagamore Hotel, pictured *c.* 1910, was built for Mabel Gooch (Mrs. William Gooch) in 1896 at a cost of $3,450. Constructed by George H. Clark, the hotel was originally two stories with a mansard roof. The Sagamore was named for the Sagamore Indians that once camped at Kennebunk Beach.

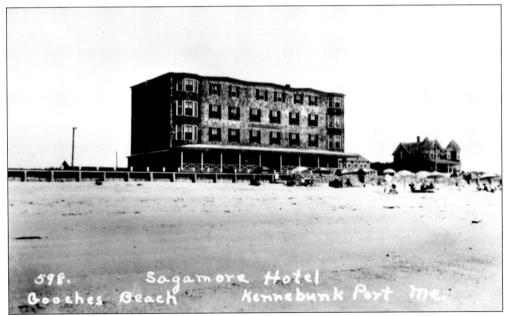

Two wings and a fourth floor were added to the Sagamore Hotel, as shown in this *c.* 1925 postcard. In 1963, Jon and Liz Milligan bought the hotel and changed the name to the Sea & Surf Motor Inn. When it was razed in 1980, the hotel was known as the Sea Spray.

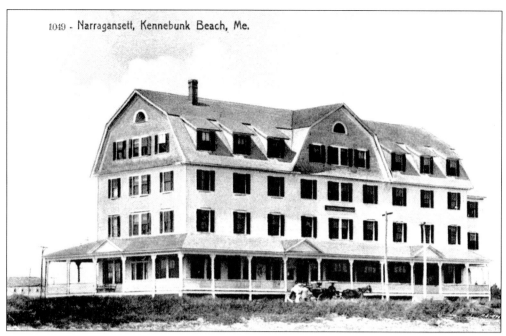

The Narragansett was built in 1904 for John Curtis on Oakes Neck, which was named for an early settler of the beach area. The hotel's accommodations included a dining room, reading room, and lobby on the first floor, and 60 rooms on the floors above. George Wentworth bought the hotel in 1921 and doubled its size soon after with an addition on the back. In 1982 the hotel was converted into condominiums.

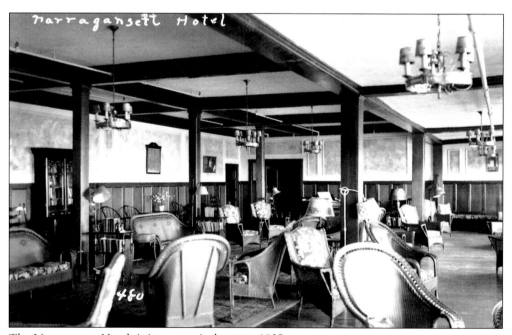

The Narragansett Hotel sitting room is shown *c.* 1935.

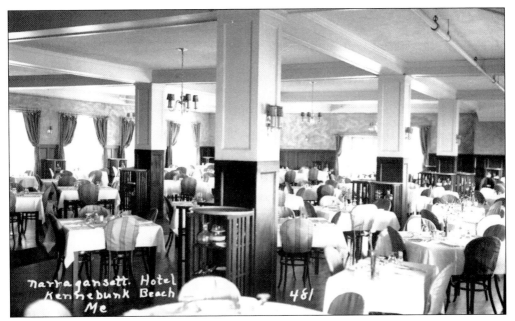

This is a view of the Narragansett Hotel dining room *c.* 1935.

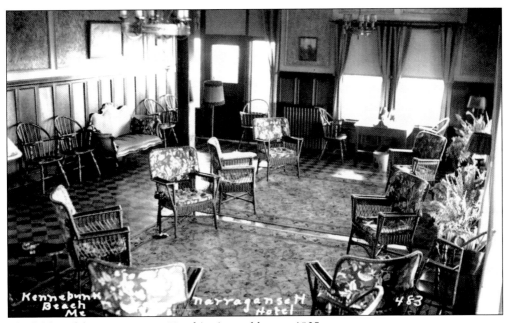

The lobby of the Narragansett Hotel is pictured here *c.* 1935.

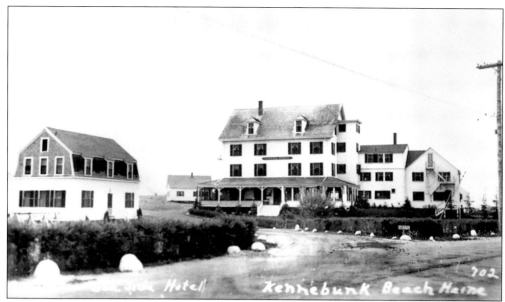

The Seaside House, located at the mouth of the Kennebunk River, has belonged to the Gooch family since the 17th century. The original King's Highway ran along the coast past the property, and the Gooch family operated a ferry that carried travelers over the river and into Kennebunkport. They also operated an inn. The earliest-known announcement of Kennebunk Beach as a place for amusement was in the *Gazette* newspaper on June 28, 1828: "Notice is hereby given that on the 4th of July good refreshments will be furnished on Gooch's Beach for the accommodation of those who may visit that agreeable resort. Pleasure boats will also be provided for those who wish to make an excursion on the water."

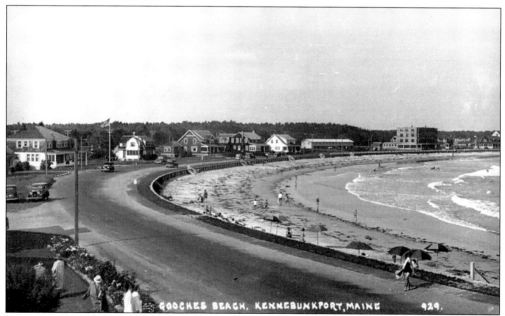

Gooch's Beach is situated at the mouth of Kennebunk River, and is the longest of the Kennebunk Beach beaches at 1.5 miles. It is named for the Gooch family, who settled there in the early 17th century.

The original Gooch home, shown here *c.* 1935, was built in the 17th century. Isaac Gooch was given the property in 1863 in exchange for caring for his parents for the rest of their lives. In 1882 he built a large addition on the old inn. This addition was razed in 1963, when the tourist trade began to wane. In 1978, the Severance family, Gooch descendants, built a new hotel on the site.

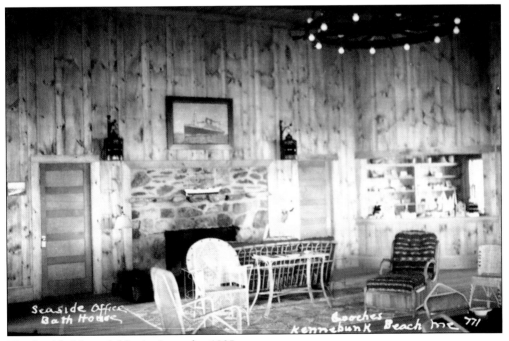

The Seaside House lobby is pictured *c.* 1935.

Bathing beauties populate Kennebunk Beach *c.* 1930. They are in front of the Narragansett Hotel on Gooch's Beach.

Five

LOWER VILLAGE

This c. 1935 view of Beach Street, looking toward Gooch's Beach, was taken from Cooper's Corner. Today, Kingsport Inn is on the left.

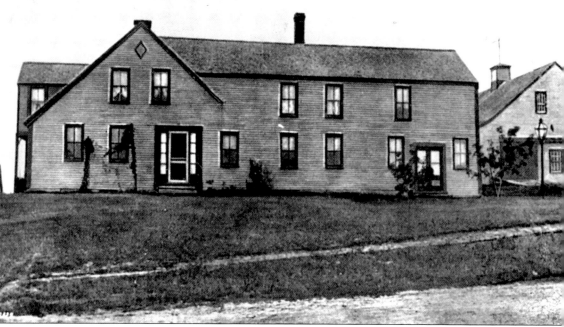

1088 - Mitchell Homestead - One of the oldest in Town - Lower Kennebunk, Me.

According to Daniel Remich in his book *History of Kennebunk*, the Jotham Mitchell House was built in 1769. Jotham was born in 1743. His father, John Mitchell, had arrived in Kennebunk *c.* 1740 and built a home on the Kennebunk River (where the Monastery is now located). In 1777, Jotham was employed on a "coaster vessel" between Kennebunk and Boston, and on the evening of December 16, he was in Boston when the famous Tea Party took place. Feeling that throwing so much tea into the harbor was a waste, Jotham took a rowboat up beside one of the ships and tried to save some of the tea to take home. He was caught, and the "scoundrels," as he called the men, tried to drown him. Jotham barely made it back to his ship alive.

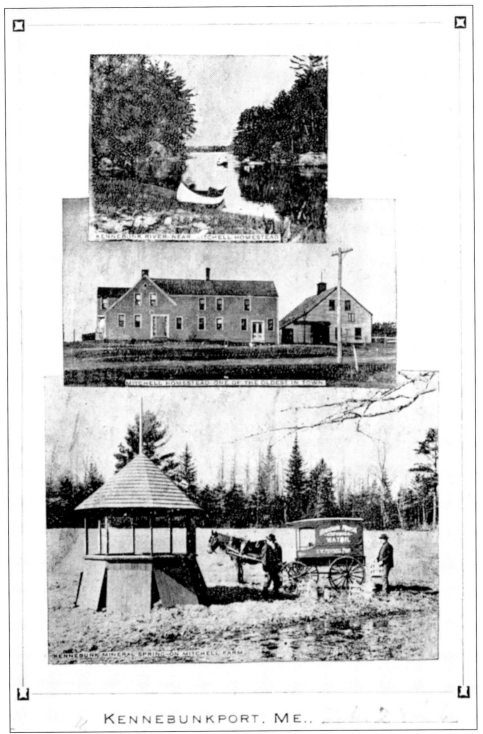

KENNEBUNKPORT, ME..

This c. 1906 three-part card shows, from top to bottom, the Kennebunk River, the John Mitchell House, and the Kennebunk Mineral Spring behind the Mitchell House. The mineral spring was operated by George W. Mitchell, the last member of the family to own the historic home.

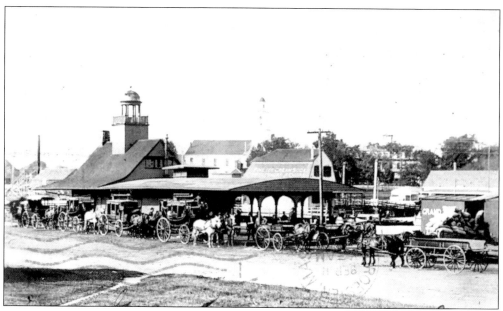

The Kennebunkport Station is shown in this *c.* 1905 view toward Dock Square, with South Church in the distance. Built in 1883, the Kennebunkport depot was on the Boston & Maine Railroad line that connected it with the station in Kennebunk. Other stations were located at Parsons Beach, Kennebunk Beach, and Grove Hill. The construction of this station spurred a building boom in Kennebunkport and Kennebunk Beach. The carriages seen lined up in front were sent from local hotels to pick up visitors and their luggage.

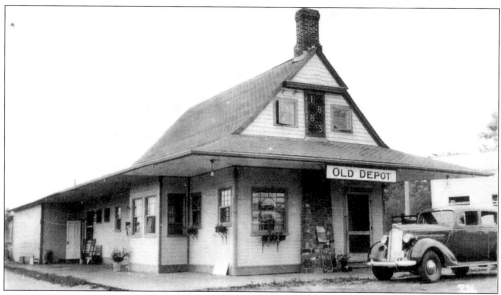

In later years, the Kennebunkport Station, shown *c.* 1935, was moved back and its bell tower and canopy were removed. The bell was given to St. Ann's Church. The station became a restaurant and later a gift shop. Today, it is known as the Pilot House.

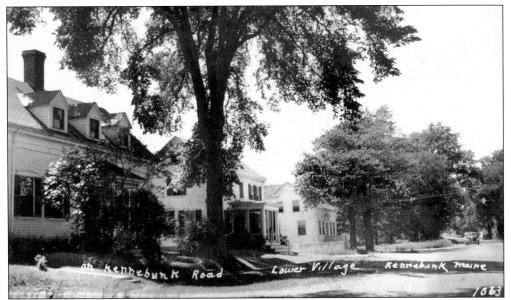

This view of the Port Road (Route 35) in Lower Village, looking toward the Landing, was taken from Cooper's Corner *c.* 1935. All of these homes have been converted for commercial use.

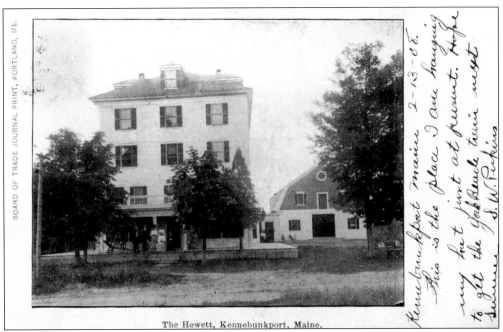

The Hewett, Kennebunkport, Maine.

The Hewett Hotel, seen *c.* 1909, was located on Beach Avenue, across from the Forest Hill House. George Hewett bought the furnished Samuel Talpey House from Talpey's son in 1905. Hewett then made a large addition of 29 rooms, shown in this postcard. In 1913, Hewett sold the hotel to John Morrison, who changed the name to the Colonial Inn, though Hewett held the mortgage. In November 1916, Morrison sold the hotel back to Hewett, who then sold it to William Rogers in January 1917. Rogers, who owned the large estate Fairfields next door, had the hotel razed and built a new home on the site for his daughter.

63

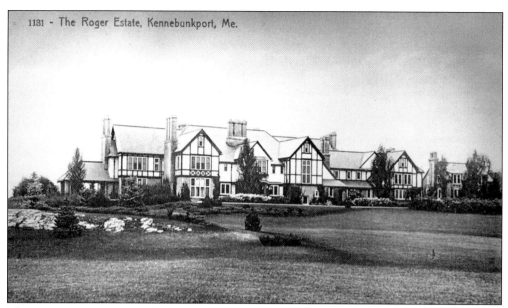

The Rogers Estate, pictured shortly after completion, is now known as the Monastery and is located across from today's White Barn Inn. John Mitchell acquired the land in 1736 from Sir William Pepperell and built a house there by 1750. William Rogers purchased the home in 1900 and had it demolished. Rogers, from Buffalo, New York, had made his money from the iron industry. The new home was designed by Buffalo architects Edward Green and William Wicks.

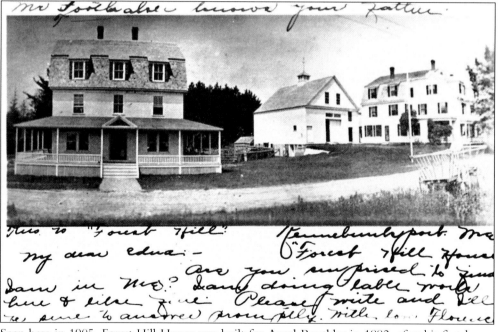

Seen here in 1905, Forest Hill House was built for Ansel Boothby in 1882, after his first home burned. The original barn on the property was saved. Forest Hill was the only, or one of the very few, hotels in the area to welcome Jewish guests. Boothby's daughter, Cora Toothacker, and her husband ran the hotel after Ansel's death and they sold it in 1937. The annex on the left was built in 1905. Today Forest Hill is known as the White Barn Inn.

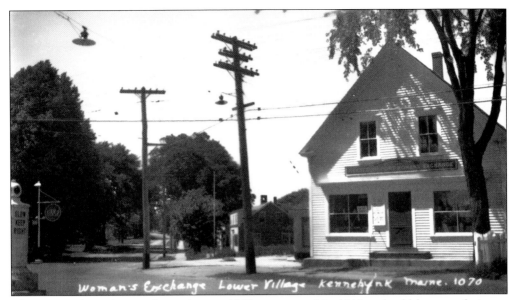

The Women's Exchange, shown here *c.* 1935, was started in 1918 and sold homemade items, baked goods, antiques, and needlework supplies. It started as a seasonal shop, and the Exchange rented shop space at different locations each summer. This building still stands, but has been moved back from the road.

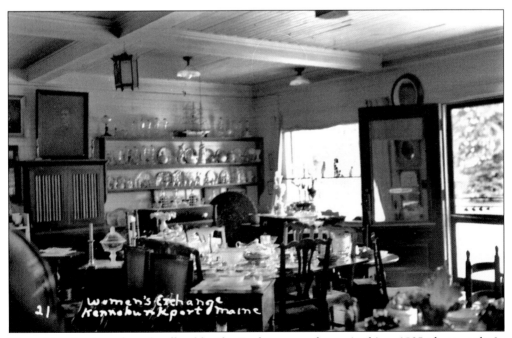

The wide selection of goods offered by the Exchange are shown in this *c.* 1935 photograph. In 1931, the shop was located in the old Whitman Studio on Ocean Avenue, but by 1935, it had moved to Lower Village and was open year round.

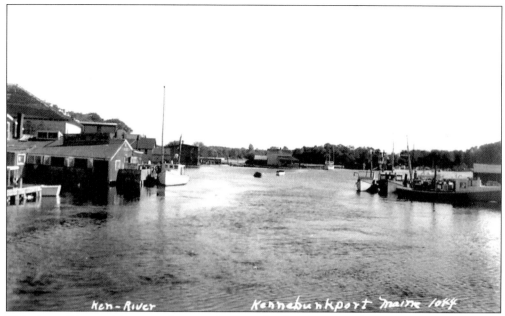

This view of the working waterfront on the Kennebunk River was taken *c.* 1930 from the bridge that connects Lower Village and Kennebunkport.

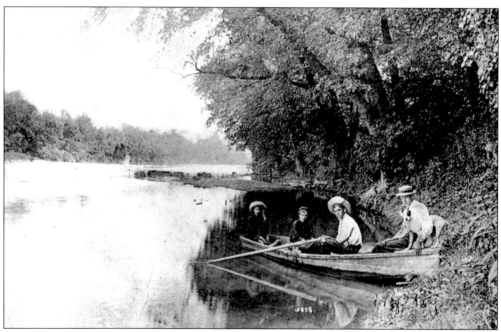

Four children and their dog take a canoe ride on the Kennebunk River *c.* 1910. Canoes represented summer pleasure to visitors of that period.

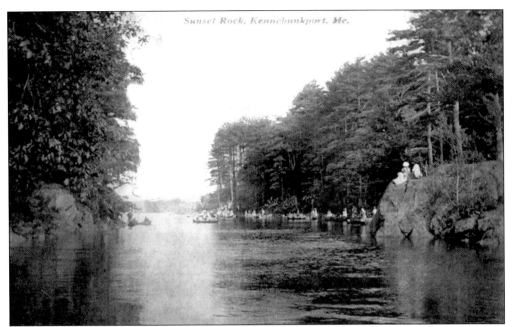

Pictured *c.* 1910, Sunset Rock (also known as Picnic Rock) was a popular landing place for canoeists boating on the Kennebunk River. Before air conditioning, visitors to the Kennebunks spent as much time outdoors as possible, seeking the coolest spot to relax. Canoeing on the river was a favorite pastime, and Sunset Rock was developed as a park for picnics. Today, Sunset Rock still remains undeveloped and is protected by the Maine chapter of the Nature Conservancy.

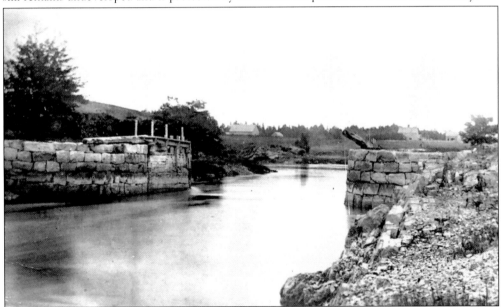

On their way to Sunset Rock, canoeists on the Kennebunk River would pass through the locks, shown here *c.* 1905. The locks were used to raise the water level so that ships built at the Landing in Kennebunk could be floated down to Kennebunkport to be outfitted. After the last ship went through in 1867, the locks remained unused until the late 19th century, when they were taken down and used for the foundation of the Davis Shoe Factory.

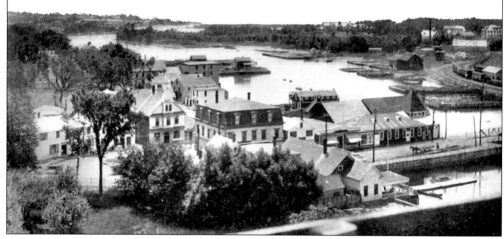

Panoramic View of Kennebunk River.

This photograph was likely taken from the roof of the Parker House on Temple Street *c.* 1915. In the foreground is the lawn of the Thompson House, which later became the Kennebunkport Inn. The Lyric Theater, formerly Tuck's Colonial Inn, is the building on the river after the bridge. The shingled Victorian building with the bay window, to the left of the Brown building (center), was constructed in the 1880s and used as the post office. Today, it is Julia's Gifts.

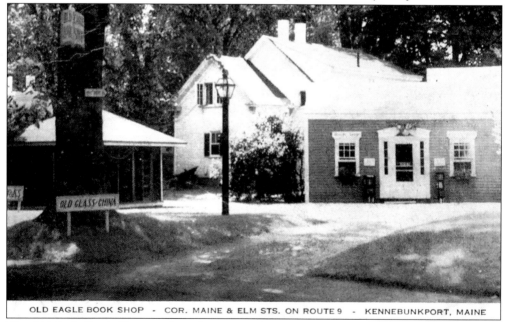

OLD EAGLE BOOK SHOP - COR. MAINE & ELM STS. ON ROUTE 9 - KENNEBUNKPORT, MAINE

The Old Eagle Book Shop stood on the corner of Elm and South Maine Streets and was owned by Copeland R. Day. Day purchased the home in 1947 and opened his business by 1948. He sold new, old, and out-of-print books, along with old glass and china. Day owned the property until 1972, when he sold it to a Belgian couple.

Six

DOCK SQUARE

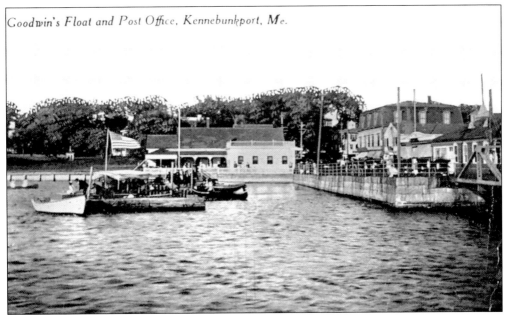

Goodwin's Float and Post Office, Kennebunkport, Me.

Goodwin's Ice Cream is seen in the center background c. 1915. Ruel Norton started in the tourist business with a hotel on this site that burned in 1893. He then built this store, where he sold cigars, fruit, and ice cream. Frank Goodwin bought the business in 1900, when Norton went on to build the Old Fort Inn and later the Breakwater. The Riverview Restaurant opened here in 1958 and was a popular place to eat for over 25 years.

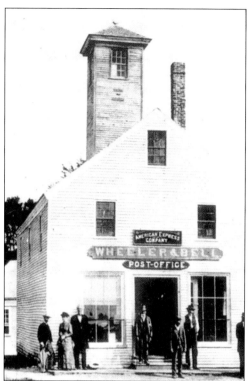

Pictured *c.* 1880, Wheeler & Bell was built for Eliphalet Perkins *c.* 1775 as a rum warehouse. John Wheeler and John Bell moved their grocery business here after their store burned in the Dock Square fire in 1877. Artist Marion Sharpe bought the building in 1963 and remodeled it into an artist studio and gallery, adding the distinctive window formation on the front. Thomas and Dorothy Jeglowsky started the Kennebunkport Book Port here in 1972; since then, the business has become a local landmark.

This is a view of Dock Square *c.* 1935. The center four buildings were erected after the fire of 1877 and all remain standing today. (Goodwin's is the last building on the right in this group.) The shops on the far right were built in 1928. The large building on the far left was constructed in 1878 and has housed several businesses over the years. (Currently Colonial Pharmacy is located there.) This Victorian-era building has been made over with Colonial features, which makes for an odd combination of styles.

The South Congregational Church was built in 1824. The front portico, added in 1912, was given by the Henry Parsons family and designed by Abbot Graves.

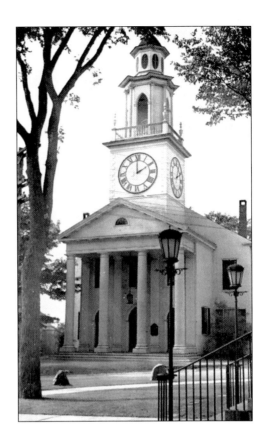

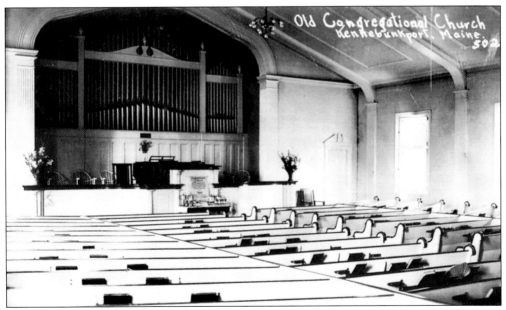

In 1843, a second floor was created by lowering the ceiling of the original sanctuary. This space was unused until 1875, when the box pews on the lower floor were moved upstairs and this sanctuary was created. The first floor then became a church hall.

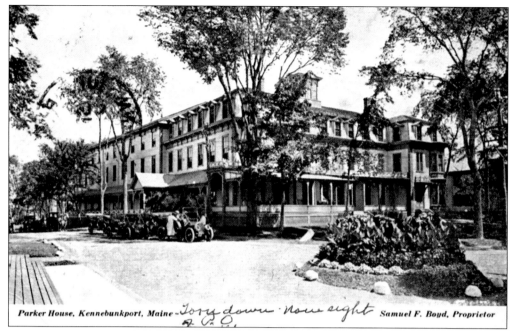

Parker House, Kennebunkport, Maine - Tory down · now eight & C. O. *Samuel F. Boyd, Proprietor*

This *c.* 1910 photograph shows the Parker House on Temple Street. The first Parker House in Dock Square had burned in the 1877 fire. Mr. Parker used his insurance money to build the new hotel, but construction costs soon left him overextended. In 1881, the hotel was auctioned off to pay his debts. By the 1890s, visitors to Kennebunkport preferred to stay along the shore, and the Parker House fell out of favor. It was razed in 1940 to make way for the new post office.

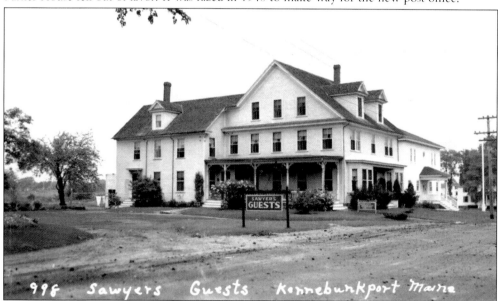

998 Sawyers Guests Kennebunkport Maine

Sawyer's Guests, seen here *c.* 1935, was a 23-room house built for Joseph Jeffery in 1896. Jeffery lost the property to foreclosure in 1909, and William Sawyer became the new owner. Sawyer's wife, Belle, was Jeffery's daughter. Belle operated the guesthouse until 1961, when she sold it to her daughter Elizabeth Arms, just a few weeks before Belle passed away. The building has been converted to apartments.

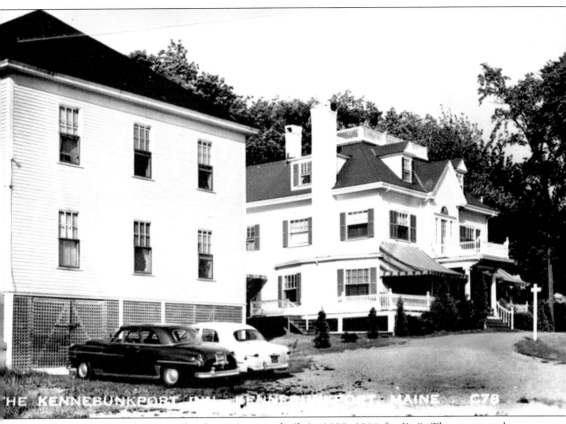

Shown here *c.* 1965, the Kennebunkport Inn was built in 1899–1900 for B. S. Thompson, who was a wealthy tea and coffee merchant. He had demolished an older home on the property and built this new house. Overlooking Dock Square, the property originally ran down to the Kennebunk River. In 1926 Lloyd and Murray Hackenburg purchased the property from Capt. Daniel Dudley, who had married Thompson's daughter Hattie. An annex was built soon after 1926 to add more rooms. The Hackenburgs opened the home as an inn and operated it seasonally until 1961, when they sold it.

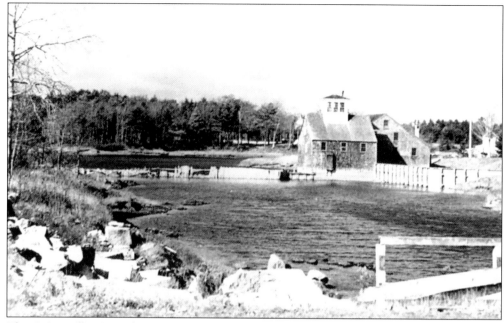

The Grist Mill, pictured *c.* 1960, located off North Street, was a tidal mill built in 1749 by Tristam Perkins. It operated as a mill until 1939, with Jim Perkins as the last miller. His daughter and her husband, Louise and Arthur Lombard, then opened the mill as a restaurant in 1940.

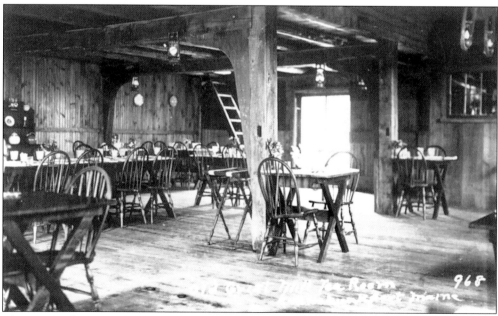

The Grist Mill interior retained all of the milling equipment, offering patrons a glimpse back to an earlier time. Unfortunately, the structure did not have a sprinkler system, which might have been able to save the restaurant when it burned on September 14, 1994. It was not rebuilt.

SHORE DINNER — ~~$~~ 4.10

Lobster Stew
Steamed Clams, Drawn Butter or Fried Clams, French Fries
Whole Lobster (Hot or Cold), Vegetables
Johnnycake Relishes
Dessert Salad Beverage

WEEK DAY LUNCHEON — $1.70

Choice of
Frapped Fruit Juice, Tomato Cocktail, Pineapple Juice
Cranberry Cocktail
Chicken Soup, Clam Chowder, Fresh Fruit Cup* or Lobster Stew*

SPECIAL OF THE DAY

Two Fresh Vegetables Salad
Dessert Beverage

CHILDREN'S SPECIAL — $1.15 — (Under 10 yrs.)

Choice of Tomato Juice, Pineapple Juice or Chicken Soup
Choice of
Broiled Fish, Sliced Chicken, Chicken a la King, Vegetables
Rolls Milk Ice Cream

SUNDAY SPECIAL

ROAST TURKEY DINNER	$2.00
(all white meat)	2.25

A LA CARTE

Lobster Stew	1.25
Fried Clams	1.50
Vegetable Plate	1.00
Clam Chowder, Large Bowl	.75
Small Bowl	.40
Steamed Clams	.90
Green Salad	.35

DESSERTS

Ice Cream	.20
Sundaes	.30
Pie	.20
Indian Pudding	.30
Fruit Cup	.25
Pie a la Mode	.35

SALADS

Served with Potato Chips
Johnnycake and Rolls

Lobster	2.75
Chicken	1.75
Fresh Fruit	1.25

BEVERAGES

Pot of Tea	.20
Pot of Coffee	.25
Iced Tea	.20
Iced Coffee	.20
Gingerale	.20
Milk	.15

SANDWICHES

Lobster	1.15
Plain Chicken	.85
Chicken Salad	.85

Please allow us time to cook your food properly. If you are in a hurry we will gladly suggest a meal which can be served quickly.

* Fruit Cup with Luncheon .15 extra
* Lobster Stew with Luncheon .40 extra

Take home a bottle of our Olde Grist Mill dressing.

Sold at Cashier's desk.

The Grist Mill's *c.* 1955 menu is seen here.

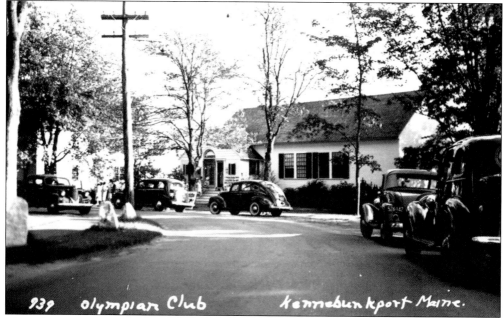

The Olympian Club, shown *c.* 1935, was built in 1929 using material from a community house located at the four corners. The Garrick Players, directed by Robert Currier, staged their first play here on July 19, 1933. Born in 1912, Currier had formed the Garrick Players in Newton, Massachusetts, in 1929. He later met writer Booth Tarkington, and began promoting his group as a resident company for Kennebunkport. Tarkington gave his support and became an active sponsor.

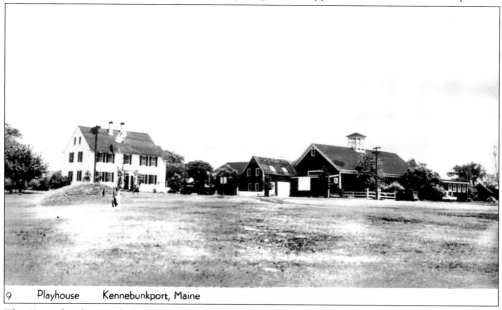

The Kennebunkport Playhouse, located on River Road, is pictured *c.* 1955. The Garrick Players were a success due to Currier's hard work. With limited means, he produced first-rate productions with top talent. By 1939, the Garrick Players had outgrown the Olympian Club. Currier then bought the Merrill Farm, across from the Arundel Golf Course on River Road, and converted the barn into a theater.

KENNEBUNKPORT PLAYHOUSE

Evenings
Monday thru Sat.
8:20
Matinees
Thurs. 2:20
Sat. 6:00

*25th Anniversary Schedule of
Stage, Screen and T.V. Stars in Person*

TELEPHONE KENNEBUNKPORT 7-3329

JULY 1-6: Hollywood's Comedy Star
JEROME COWAN
in the hilarious prize comedy
"THE SILVER WHISTLE" with Frances **Brandt**

JULY 8-13: The King of Comedy
EDWARD EVERETT HORTON
in the NEW Broadway success
"THE RELUCTANT DEBUTANT"
with Norma Winters

JULY 15-20: By Popular Demand
EDWARD EVERETT HORTON
in the famous FUN comedy
"HARVEY" with Elizabeth Kerr

JULY 22-27: Dancing Star of "Oklahoma"
JAMES MITCHELL
in the thrilling spectacle
"DARK OF THE MOON" with Patricia Peardon

JULY 29-AUG. 4: TV's Favorite Comedian
HENRY MORGAN
in the movie-television hit
"FATHER OF THE BRIDE" with Anna Minot
No Perf. Wed. — Extra Perf. Sun. Aug. 4

AUG. 5-11: The Outstanding Star
FAYE EMERSON
in Agatha Christie's Mystery Hit
"WITNESS FOR THE PROSECUTION"
No Perf. Wed. — Extra Perf. Sun. Aug. 11

Opens Tuesday Aug. 13 thru Sunday Aug. 18
Star of "Call Me Madam"
RUSSELL NYPE
in a Musical Farce "PETTICOAT FEVER"
Orchestra under Direction of ERNEST BRAGG

Opens TUES. Aug. 20: The Glamour Singing Star
JANE MORGAN
in Cole Porter's Smash Musical Hit
"CAN - CAN" with Marcel Le Bon

BOX-OFFICE OPEN 9 A.M. to 10 P.M.

Pictured is a bill of plays for the Kennebunkport Playhouse's 1955 season. In 1949, tragedy struck when the playhouse burned just a few hours after the last play of the season had finished. To rebuild the theater, Currier found another barn and had it dismantled and reassembled on River Road. In 1964, the playhouse was the only theater in the United States under operation by the same man for over 30 years. Currier sold the theater in 1965, and in 1971 a second fire destroyed the playhouse. It was not rebuilt.

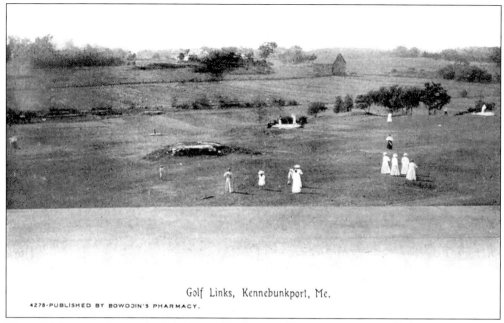

Golf Links, Kennebunkport, Me.

Though this postcard states that it is a Kennebunkport golf course, it may actually be in Kennebunk. Many Kennebunk Beach hotels and Lower Village businesses are listed as being in Kennebunkport, when they are really in Kennebunk. Mention to anyone that you live in Kennebunk, and people will say, "Yes, that's where President Bush lives." "Well, no," you respond, "the president lives in Texas, but his father, the former president, summers in Kennebunkport." These are two separate towns with two separate governments! If this course is indeed located in Kennebunkport, it is the Arundel Golf Club. The Bushes often play golf here.

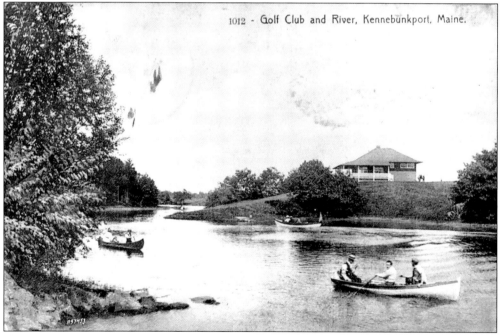

1012 - Golf Club and River, Kennebunkport, Maine.

Shown here is the clubhouse at the Arundel Golf Club on the Kennebunk River, off River Road.

Seven

OCEAN AVENUE

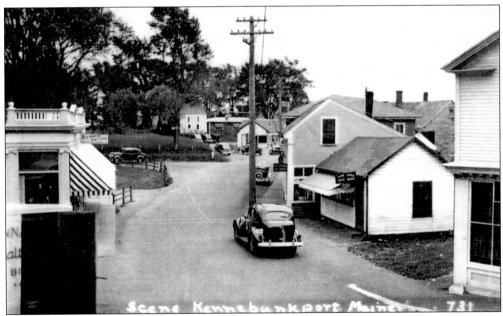

Arundel Square, seen here *c.* 1945, just off Dock Square, marks the start of Ocean Avenue. These buildings still stand and are used for shops today.

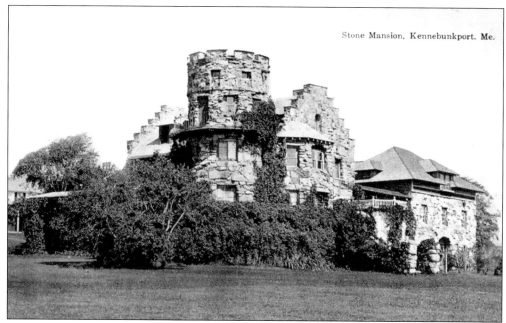

Stone Mansion, Kennebunkport. Me.

Pictured *c.* 1900, the Castle was owned by the Clark family and was built after their first cottage burned down. This building was constructed from stones collected along the beaches. Unfortunately, those stones made the house damp, and over time, salt from the stones in the three-foot-thick walls began to leach out, making the cottage unlivable. Edward Robertson later purchased the property, tore down the cottage, and built the new cottage pictured below.

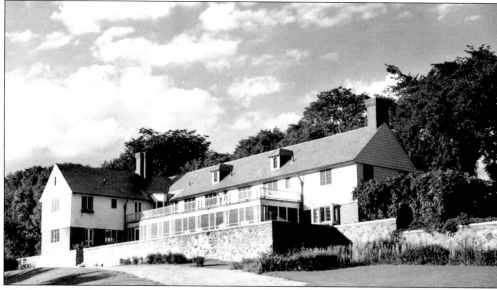

This house was built for Edward Robertson of Columbia, South Carolina, in 1911, at a cost of $166,000. Overlooking the river, the home required so many servants that Robertson added a wing on the north side to house them and an apartment over the garage for his chauffeur. In 1950 Donald and Alice Kimball bought the mansion and opened it as a restaurant and inn called the Garrison House. The name was later changed to the Port House. In 2003–2004, a spectacular renovation returned the hotel to a private home.

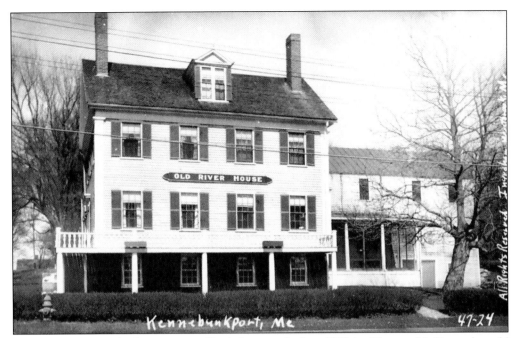

The River House, also known as Mailing's Inn, was built *c.* 1852 by Thomas Mailing, who sold it to John B. Mailing in 1858. John Mailing was a boat builder and rigger, and he used the home as a boardinghouse. After John's death in 1893, the River House remained in the Mailing family until 1929, when it was sold to Cora Howland of Chicago. In 1932 Rufus Twombly acquired the property and furnishings in lieu of payment for his plumbing services. George and Adelaide Day bought the home in 1934 and opened it as the Old River House.

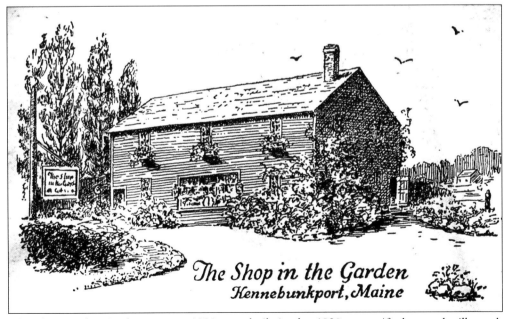

The Shop in the Garden, seen *c.* 1930, was built in the 1920s as a gift shop and still stands on Ocean Avenue.

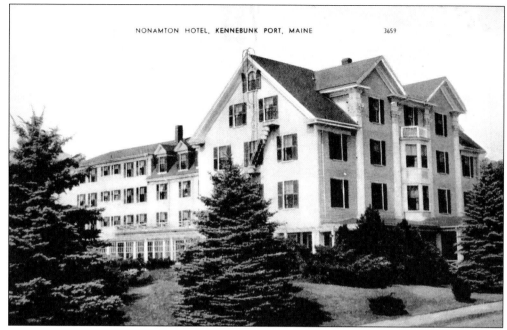

Pictured *c.* 1935, the Nonantum Hotel was built for Capt. Henry Heckman in 1884. It is one of the few hotels from that era still standing and in operation. After Heckman's death in 1920, the hotel was sold to Felix Bridger, who also owned the Thatcher Hotel in Biddeford.

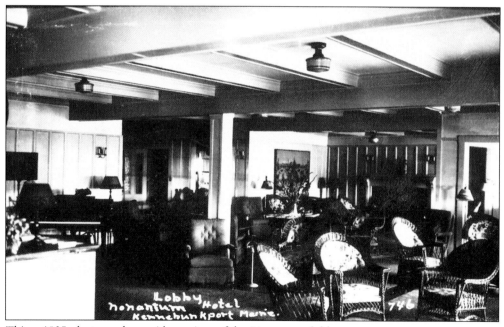

This *c.* 1935 photograph provides a view of the Nonantum lobby.

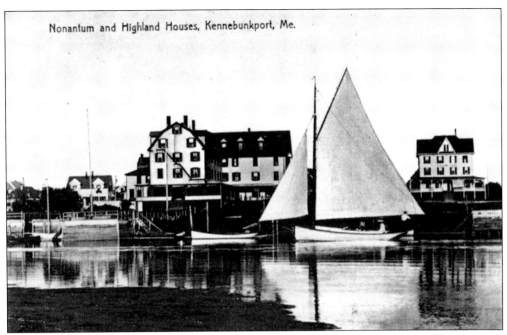

Nonantum and Highland Houses, Kennebunkport, Me.

The Nonantum Hotel is seen here from the Kennebunk River. To the right is the Highland House.

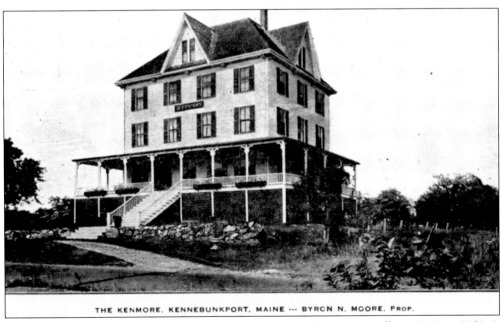

THE KENMORE, KENNEBUNKPORT, MAINE --- BYRON N. MOORE, PROP.

The Kenmore began as the Highland House and was built for Orren Wells in 1881. In 1928, it was remodeled as an annex to the Nonantum. It burned in 1934.

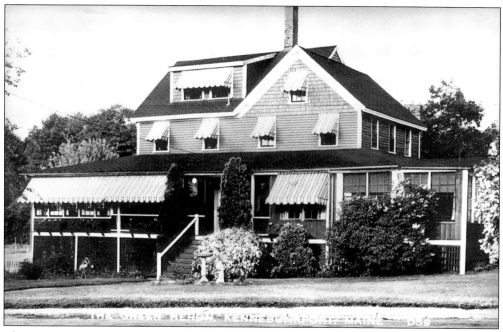

The Green Heron is shown *c.* 1955. When Hamlin Littlefield purchased the property in 1908, it contained a store that had been built after 1885. The store was operated by Mr. Wilband, who sold drinks, fancy chocolates, and ice cream. In 1907, a tea room occupied the store. Littlefield most likely converted the store into a boardinghouse, which his daughter-in-law Ellen Littlefield operated. Charles Cole bought the inn in 1963 from William Hoyt, who had operated it for nine years. Still in business, the Green Heron has had several owners since 1963.

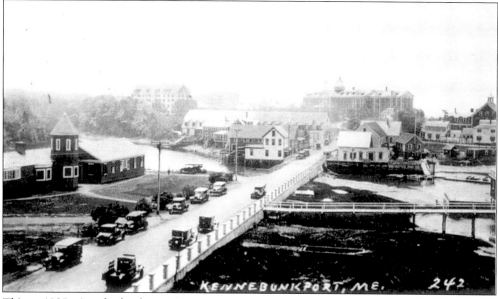

This *c.* 1935 view looks down Ocean Avenue toward Cape Arundel. On the far left is the reconstructed Arundel Casino; above that is the Oceanic. The large building in the middle is a garage for the Breakwater Court Hotel (now the Colony), which appears on the right. On the far right, with the cupola, is the Riverside House.

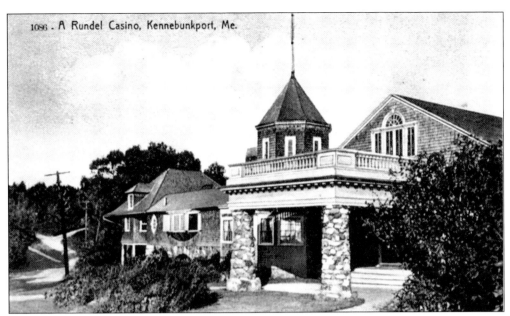

This misprinted card, captioned "A Rundel" instead of "Arundel," was produced c. 1915 and shows the Arundel Casino at its original location on the old King's Highway. In 1929 the casino and the Kennebunk River Club merged, and most of the casino structure was relocated to Ocean Avenue, where it stands today. The last section of the casino, with the hip roof, remained on the old King's Highway, and was converted to a cottage.

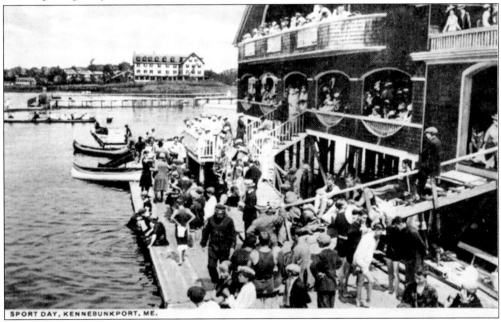

In the early 1900s, Sport Day (or the River Carnival) marked the middle of the summer season, which officially began July 4th and ended Labor Day. Sponsored by the Kennebunk River Club, the carnival included a nighttime parade of watercraft, all decorated and lit with lanterns. The waterfront hotels and cottages were decorated with lanterns, bunting, and flowers. Buckboards brought in people from other towns to enjoy the day, which climaxed in fireworks and a huge bonfire.

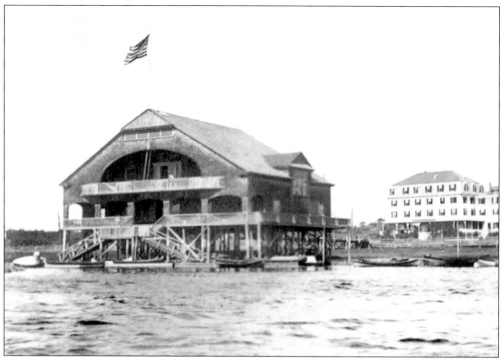

The Kennebunk River Club on Ocean Avenue started as the Lobster Boat and Canoe Club in the late 1880s and was formally organized as the Kennebunk River Club in 1889. Designed by architect Frederick W. Stickney, the clubhouse was built in 1890. The club became a popular meeting place for summer visitors and also developed and sponsored many sporting and social events.

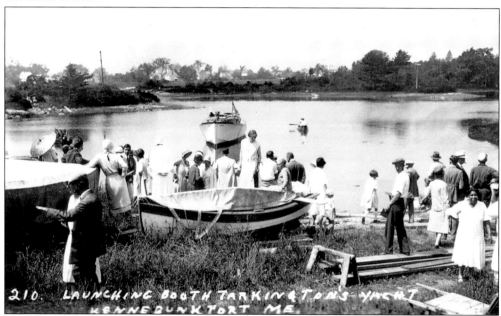

Booth Tarkington's yacht is launched in 1930. This may have been the *Zanti*, which was built at the Clement Clark Shipyard in Lower Village.

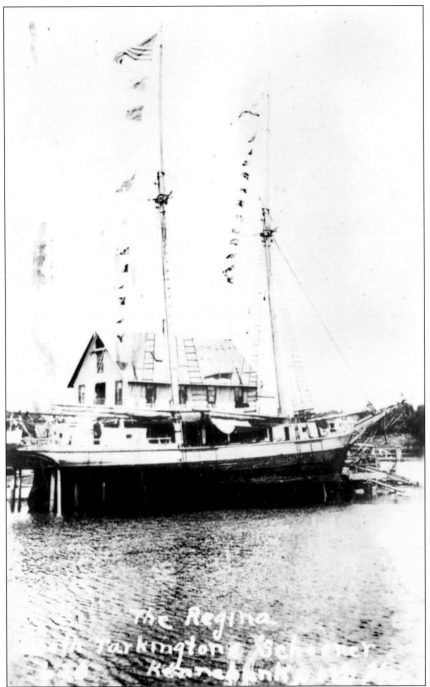

Booth Tarkington used *The Regina*, shown here, as a writing studio, and for many years, it was a well-known landmark on Ocean Avenue. Tarkington bought her at public auction in 1929, and had the schooner set in a cement cradle next to his boathouse. *The Regina*, a coastal packet, schooner-rigged, was built in 1891 at Machias. During World War I, she carried lumber from Canada to New York, most of which was sent to Europe to build docks at Brest. In 1952, she was taken out to sea and sunk.

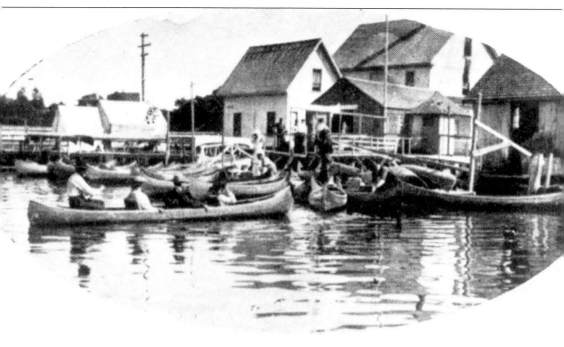

Indian Canoe Landing, Kennebunkport, Maine

Indian Canoe Landing was located off Ocean Avenue on the Kennebunk River, almost opposite the Colony Hotel. Native Americans from the Passamaquoddy, Penobscot, and Abenaki tribes spent summers at Kennebunkport making baskets, canoes, and other handicrafts, which they sold to tourists. These Native Americans continued coming to Kennebunkport until the 1930s. In 1936, the last of the camps was torn down by John Peabody, whose father, Henry, owned the land the people had camped on. When they were children, Lucy Nicola and Louis Sockalexis both visited Kennebunkport with their parents. Lucy became "Princess Watahwaso," a well-known singer who performed Native American–themed songs in the first two decades of the 1900s. As an adult, she owned a summer house in Kennebunkport. Louis became a star pitcher and outfielder at both Holy Cross and Notre Dame. He became the first recognized Native American to play baseball. Louis was an outstanding athlete, but a leg injury ended his career in 1899, when he was 27.

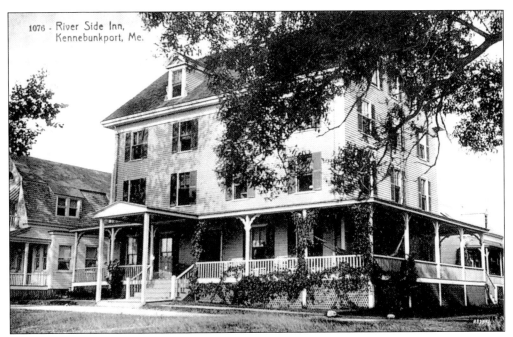

The Riverside Inn stands on the banks of the Kennebunk River, opposite the Colony Hotel. It was built for George Gooch in 1883, and was sold to Herbert Hutchins in 1902. In 1919, Elizabeth Shannon bought the hotel from Fred B. Tuck. She also owned the Arundel Inn next door. In 1945, when Shannon died, she left both inns to Wallace Reid. Today, the Riverside, the Sommerlyst (to the left), and the Arundel Inn make up the Breakwater Inn.

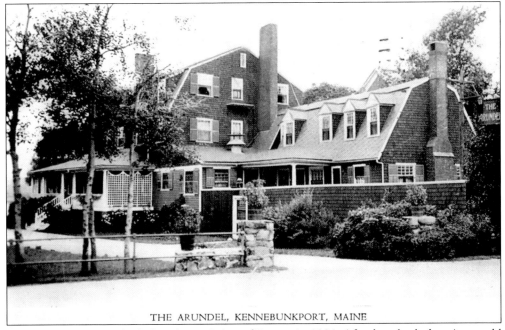

The Arundel Inn was built for Alice I. Paine of Boston in 1884. After her death, her sisters sold the inn to Charles Marshall, who made it over as his private home. Elizabeth Shannon, who was from Ireland, purchased the property in 1913 and reopened it as an inn.

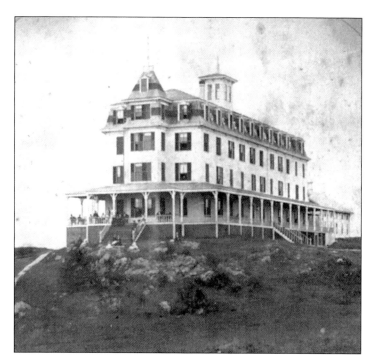

The Ocean Bluff Hotel was built in 1873, the first of the grand hotels to be constructed in the Kennebunks. It was designed by architect and Kennebunk native Joseph Mendum Littlefield. The Ocean Bluff was located on the Sea Shore Company's premier lot on Ocean Avenue, and was situated on a high bluff facing the ocean. Commanding the finest views and coolest summer breezes, it was an immediate success. Stimpson and Devnell operated the hotel until it burned in January 1898, while a new addition was under construction.

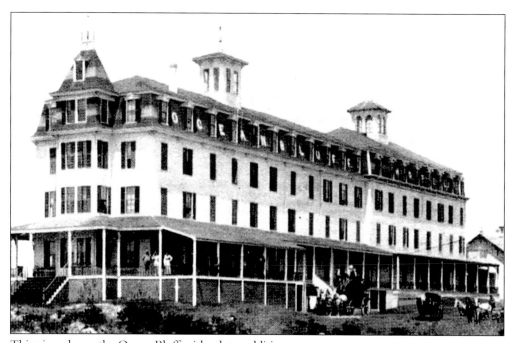

This view shows the Ocean Bluff with a later addition.

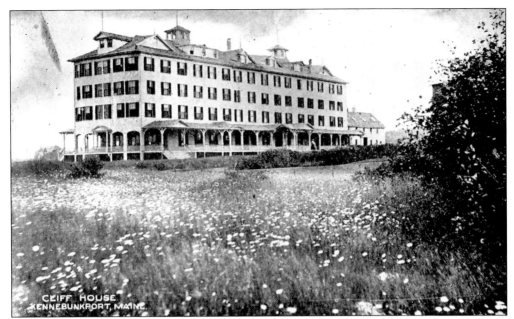

The Cliff House, located near the Ocean Bluff Hotel, was built for B. F. Eldridge in 1881. Originally two stories with a mansard roof, it was enlarged in 1897. The Cliff House burned on September 23, 1923, and was not rebuilt.

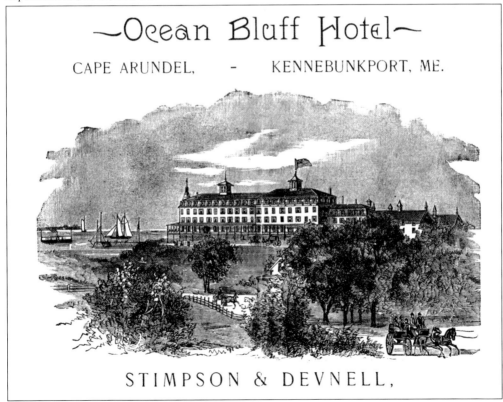

This brochure was printed for the Ocean Bluff c. 1885.

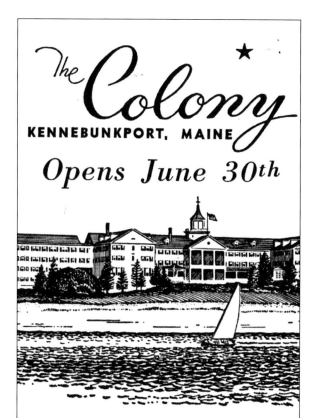

The Colony

KENNEBUNKPORT, MAINE

Opens June 30th

Beautifully situated overlooking beach, ocean and river. Well-appointed guest rooms for 200 . . . dining room features New England dishes . . . cocktail bar . . . spacious porches and lounges . . . game rooms. Safe surf bathing, beautiful beach. Two 18-hole golf courses, riding, sailing, fishing, tennis. Movies, shops, Summer Theatre and Churches nearby. American Plan. Advance reservations necessary.

★ The Colony

BOX 566G, KENNEBUNKPORT, MAINE

FORMERLY BREAKWATER COURT

Boughton Ownership Management • In Winter—
The Colony, Delray Beach, Florida

N. Y. Reservation Off., 630 5th Ave., CIrcle 6-6820

This advertisement promotes the Colony Hotel, formerly the Breakwater Court.

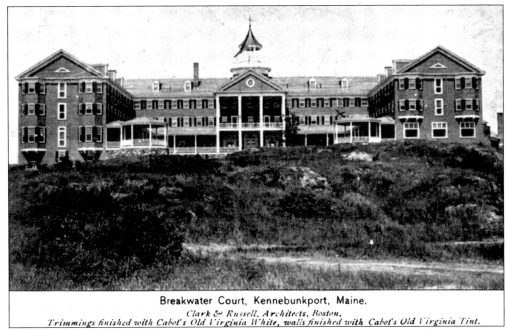

Breakwater Court, Kennebunkport, Maine.
Clark & Russell, Architects, Boston.
Trimmings finished with Cabot's Old Virginia White, walls finished with Cabot's Old Virginia Tint.

The Breakwater Court is pictured *c.* 1920. After the Ocean Bluff Hotel burned, the directors of the Sea Shore Company voted not to rebuild. The site remained vacant until Ruel Norton purchased it in 1908. Norton then built the Breakwater Court, using architects Clark & Russell of Boston. The current owners of the property, the Boughton family, bought the hotel in 1948 and renamed it the Colony.

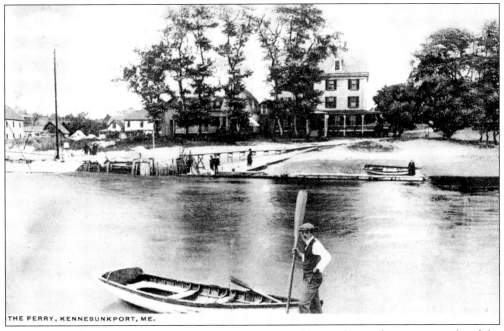

THE FERRY, KENNEBUNKPORT, ME.

The ferry ran between the wharf shown here and Gooch's Beach, on the opposite side of the Kennebunk River. The Gooch family operated a ferry here in the 18th century for people traveling on the King's Highway, which followed the shore.

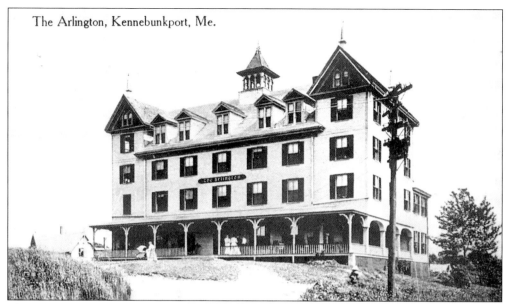

The Arlington, Kennebunkport, Me.

The Arlington, shown *c.* 1910, was originally built for John Bickford in 1886 and was known as the Bickford. It was enlarged in 1895. Bickford sold the hotel to Lizzie Stone Cleaves, who renamed it the Arlington. Jon Milligan bought the hotel in 1968 and converted it to apartments. The porch and dormers were removed when the building was made into condominiums in 1980.

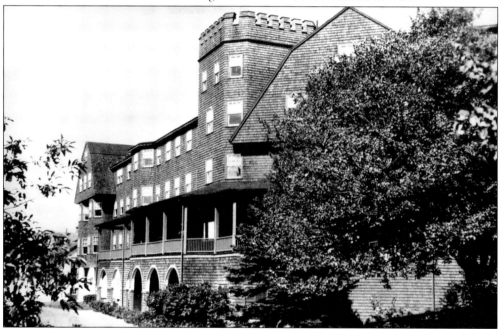

The Old Fort Inn, pictured *c.* 1920, was built for Ruel Norton in 1901. It was designed by Clark & Russell of Boston, who were inspired by an early-19th-century fort that had once stood where St. Ann's Church is today. The Old Fort Inn reigned over Cape Arundel until Norton had the Breakwater Court built in 1914. Maurice Sherman was the Old Fort's last owner; after his death in 1962, the inn was closed for five years and demolished in 1967. A rear service wing was later converted to a small inn, which operates today.

OLD FORT INN
KENNEBUNKPORT, MAINE

The Inn is modern in all respects. Every room is furnished with a long distance and local telephone. There is a private bath with every suite—with almost every room. Electric lights, elevator, barber shop, &c.

Golf course (18 holes), Sailing, Fishing, Bathing, Canoeing, Dancing.

Season: 1916, June 15th to September 11th, inc.

Garage in connection.

NEVIN & DUFFIELD - - - **Proprietors**

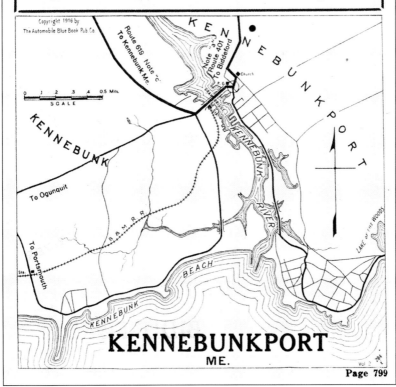

Page 799

This 1916 advertisement promotes the Old Fort Inn.

95

One of Kennebunkport's drawing points is its historic homes that line the streets of town. Many of these houses were once shaded by tall elms. Romantic postcards like this one printed in the early 1900s reminded people of an earlier time. Today, many of Kennebunkport's older homes have been altered or so overly restored in the last 25 years that they no longer retain any of the original features that made them so unique.

Eight

KENNEBUNKPORT HOMES

The Benjamin Coes House, seen here *c.* 1915, was built in 1795. Coes used the first two floors as his home and the third floor as a sailmaker's loft with an outside staircase. The Coes family owned the home until 1915, when the Burrage family purchased it. While renting the house from the Burrages, Abbot Graves removed the original front door that is seen here, and replaced it with another one. In 1929, the Burrage family moved the house sideways, placing it against the *c.* 1860 Davis House. This created a grand, 14-room Colonial Revival mansion. The Davis House was gutted and a huge living room was formed on the first floor. On the walls of this room, Mildred Burrage, a noted Maine artist, painted murals featuring historic homes and landmarks of Kennebunkport.

The Greek Revival–style Nott House was built in 1851 for Eliphalet Perkins, who sold it in 1853 to his son Charles. Today, the home belongs to the Kennebunkport Historical Society and is open to visitors in the summer. It was given to the society by Celia Nott, in memory of her brother. The home is still decorated as it was during the Civil War, and contains portraits and furnishings belonging to the Perkins/Nott family.

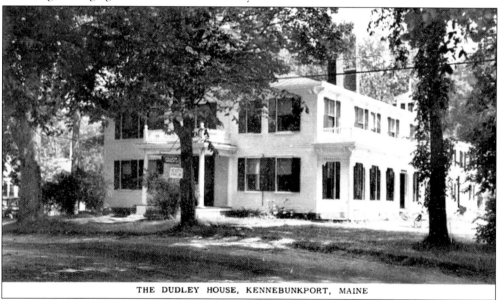

THE DUDLEY HOUSE, KENNEBUNKPORT, MAINE

Pictured *c.* 1955, the Captain Dudley House on Elm Street was built for the Perkins family in 1806, and was sold to Captain Dudley's father in 1849. Daniel Webster Dudley, a ship's captain born in 1841, went to sea in 1852, and at age 23 captained his first ship. On his trips, Dudley collected souvenirs, and by the time he retired in 1900, his home was filled with all kinds of treasures. Dudley died in 1930 and his son sold the property. In 1950, the Nabors purchased the home and opened it as a guesthouse.

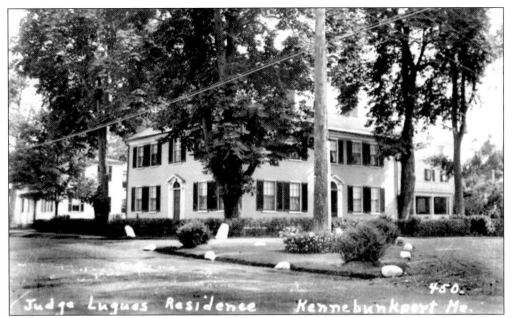

Shown here *c.* 1935, the Nowell-Luques House, on the corner of Union and South Maine Streets, was completed in 1805 for Brig. Simon Nowell. Nowell operated a tavern here, before he lost the home to John Lord in a lawsuit. In 1836 Lord sold the home to Andrew Luques, whose family occupied the house until 1947. In 1925, local artist Louis Norton was commissioned to paint murals in several of the rooms.

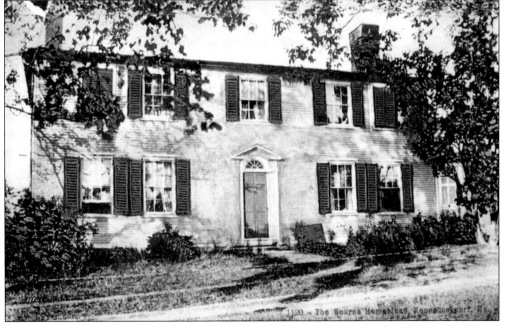

The Bourne House on North Street is a classic Federal-style home built in the early 1800s. Since the time of this photograph, the exterior has been altered and sidelights have been added to the front door.

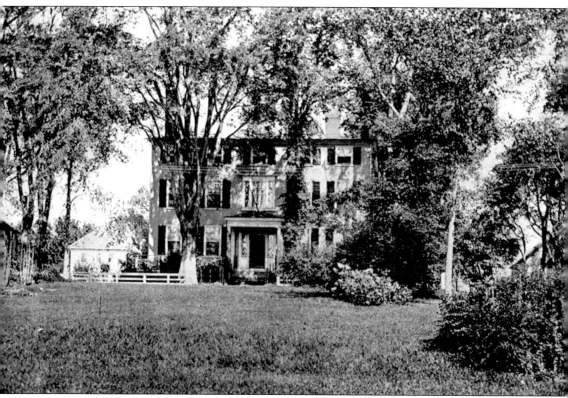

This three-story home was built for Nathaniel Lord in 1812, likely as a way to keep idle ship workers busy during the British blockade. Lord died as the house neared completion in 1815, and his family moved in without him. Later generations used it as a summer home. Interestingly, the house was always passed down from daughter to daughter through the Lord, Clark, Buckland, and Fuller families. Eight generations of Lord descendants had lived in the house, and it was filled with antiques, family papers, and other treasures, which were all auctioned off when Lucy Parry sold the house in 1972. Jim Throumoulos purchased the home, restored it, and opened it as a bed and breakfast. Current owners Rick and Beverly Litchfield bought the property in 1978 and continued Throumoulos's work of preserving and maintaining the home as an inn.

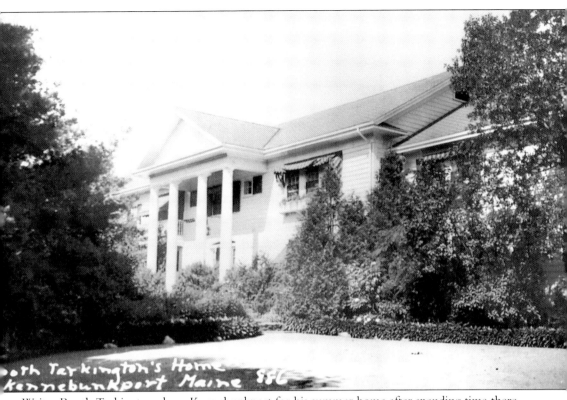

oth Tarkington's Home
Kennebunkport Maine 556

Writer Booth Tarkington chose Kennebunkport for his summer home after spending time there in 1903 while recovering from typhoid fever. His summer residence, shown here *c.* 1935, was built in 1916 and named Seawood. Known as "the Gentleman from Indiana," Tarkington, born in Indianapolis in 1869, used his experiences growing up in the Midwest as the basis of many of his novels. Tarkington won two Pulitzer Prizes. He also wrote plays, and several of his books were made into films, including *The Magnificent Ambersons.* Tarkington died in 1946. Seawood was converted to condominiums in the 1980s, and Tarkington's library became a garage.

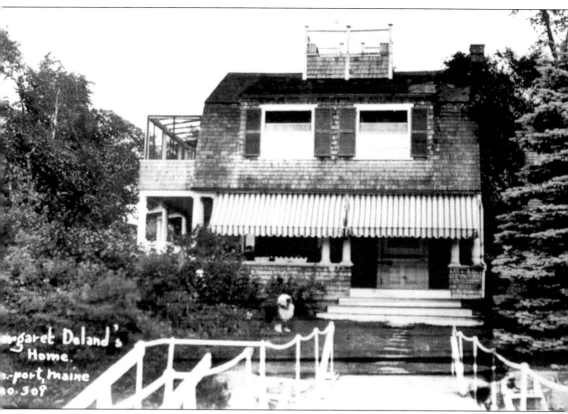

Margaret Deland's summer cottage, Greywood, pictured *c.* 1935, was a place she enjoyed for 50 years, until her death in 1945. She owned another cottage farther down Ocean Avenue, which she used in the fall. Little known today, Deland first published a collection of poems in 1886, and published her first novel, *John Ward, Preacher,* in 1887. By 1941, she had published 33 books, with the *Old Chester Tales* series being the most popular. Born in Pennsylvania in 1857, Deland was active in important social causes of the era. At the age of 60, she did relief work in France during World War I and was awarded the Legion of Honor. Deland's obituary in the *Kennebunk Star* noted that she and her husband came to Kennebunkport "during the period before wealthy visitors turned the village into an exclusive summer resort." Her summer home on the banks of the Kennebunk River still stands.

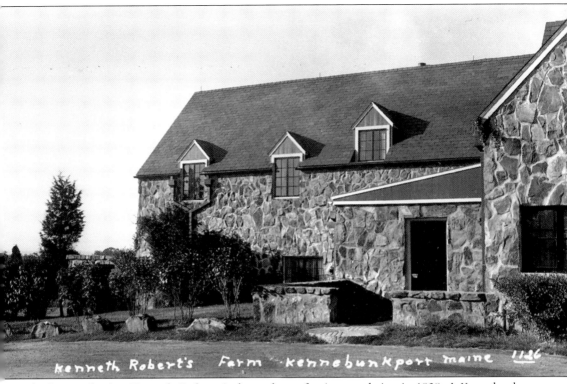

Kenneth Robert's Farm - Kennebunkport maine 1186

The home of writer Kenneth Roberts is shown here after its completion in 1938. A Kennebunk native, Roberts spent summers at Kennebunk Beach with his wife, Ann. Eventually they had enough of the beach and the constant interruptions, so Roberts purchased land in Wildes District that abutted the estate of his friend Booth Tarkington. The new Roberts home was named Rocky Pastures. On the gate Roberts installed at the bottom of his driveway was a sign that read: "This Gate is kept closed because uninvited sightseers ruin lawns, broke trees, ran off the road, put the dogs into an uproar, raised hell out of idle curiosity, and interfered with work." Roberts wrote historic novels that mixed fact and fiction, and he was noted for his excellent research. His home burned during a blizzard on Christmas Day 1975. The house was rebuilt with a modern plan.

Abbot Graves's summer home on Ocean Avenue was built in 1905 from plans he designed himself. Graves started out as an architect but ended up an artist. Best known for his floral paintings, he also painted still lifes, seascapes, landscapes, and portraits. He would often use local people as models for his paintings. Active in local affairs, Graves bought the old customs house and gave it to the town to use as a library, in memory of his son. He also served on the Village Improvement Committee. Like Booth Tarkington and Margaret Deland, Graves was popular with the townspeople and often opened his home and studio to raise money for local causes. His summer home was unusual for the area, as it was built in the Prairie style made popular by Frank Lloyd Wright. Graves died at the age of 77 in 1936.

Nine

CAPE ARUNDEL

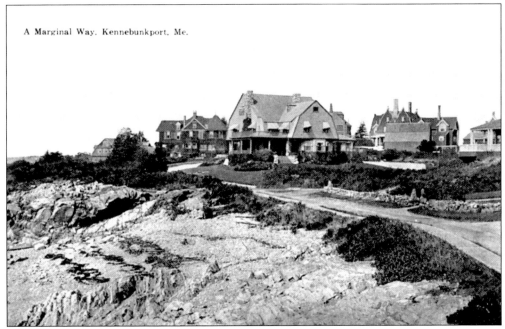

A Marginal Way, Kennebunkport, Me.

These summer cottages on Ocean Avenue, overlooking the Atlantic, were built for middle- and upper-class summer residents, and were used just two or three months each year. The cottage in the foreground, called Inglesea, was built for Dr. Frederick Brooks of New York City in 1889. It was enlarged in 1903 for the next owner, Lucy Fay. Just behind it is the Talbot Cottage, with the Flemish gables.

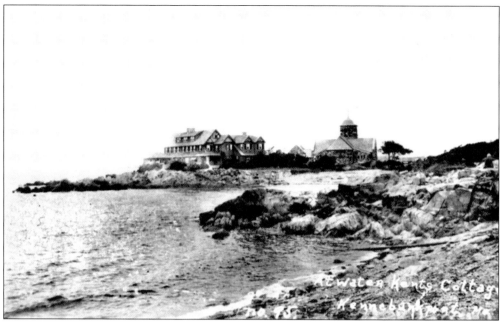

Built for Julia and Mary Nesmith in 1891, this cottage was purchased in 1910 by Atwater Kent, who then enlarged it. Kent created the first affordable radio and also invented and patented the modern ignition system for automobiles. In 1937, with 97 patents to his name, Kent retired, liquidated his business, and sold all his homes. He then moved to Hollywood, where he quickly became known for his star-studded parties.

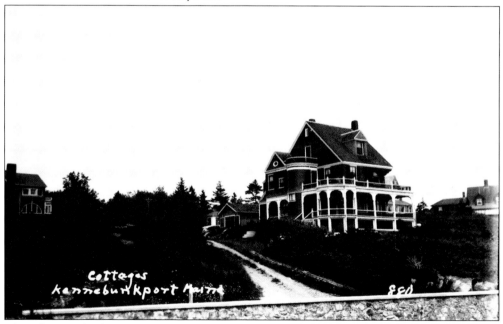

The John Towbridge Cottage is pictured *c.* 1935. Constructed in 1887, it was one of the first cottages built on Cape Arundel. Towbridge was the first director of the Sea Shore Company, which had purchased the land at Cape Arundel for development. He was also a well-known writer of books and short stories for boys.

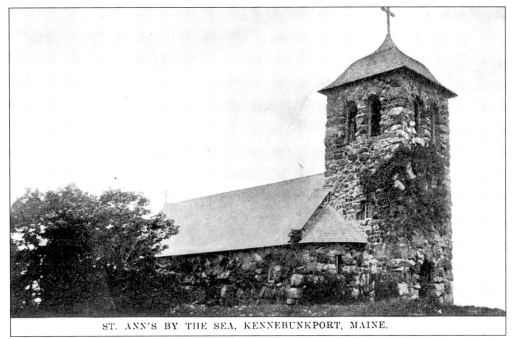

ST. ANN'S BY THE SEA, KENNEBUNKPORT, MAINE.

In 1887, architect Henry Paston Clark of Boston was commissioned to design St. Ann's church for summer residents of the Cape Arundel area. Built of rough stones, it was based on medieval English churches. St. Ann's was placed on a grassy knoll off Ocean Avenue, facing out to sea. Clark also designed several cottages at Cape Arundel.

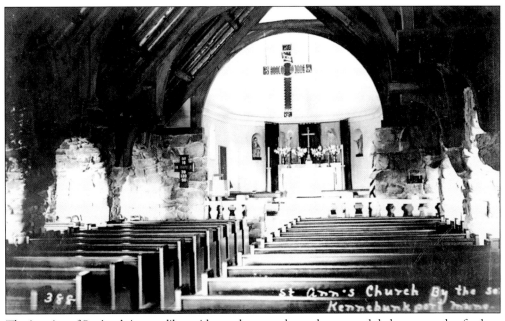

The interior of St. Ann's is cave-like, with rough stones, heavy beams, and dark pews made of oak.

107

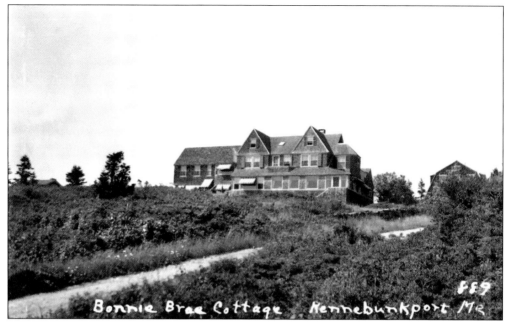

Bonnie Brae Cottage, shown here *c.* 1935, was built in 1894 for E. H. Bronson. Designed in the shingle style by John Calvin Stevens, it is clad in shingles, with a stone foundation and chimney typical of the style. These types of homes appear to have grown out of the ground, which is what the architects intended. The shingle style was popular at the end of the 19th century, and examples can be found along the New England coastline. In 1924, Mrs. Charles P. Rimmer expanded the cottage with an addition on the west side designed by architects Clark & Russell.

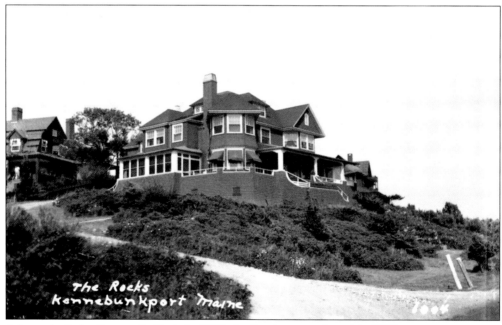

A house built for George G. Davis in 1895, the Rocks was enlarged in 1907.

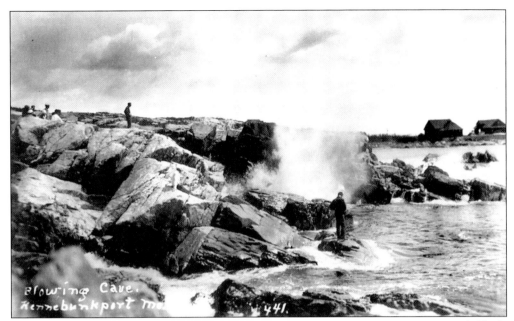

Blowing Cave at Cape Arundel is a natural formation in the rocks that causes seawater at half tide to spray up, often by as much as 40 feet. A local legend attributes the phenomenon to two Native American lovers, forbidden to marry by their respective tribes, who jumped off the rocks here. The cave and the land were given to the town by Henry Parsons to ensure that visitors would always be able to witness the phenomenon and enjoy the views.

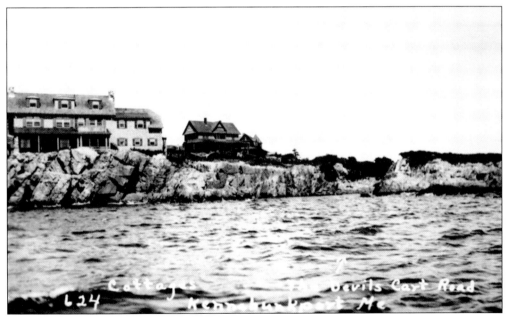

The Devil's Cart Road is another natural formation along the shore of Cape Arundel. Here, ruts have appeared in the flat rock as if formed by a cart on a dirt road. Some say it was the devil's cart coming up from under the ocean and going back down again, leaving gaps and drop-offs 25 to 30 feet wide.

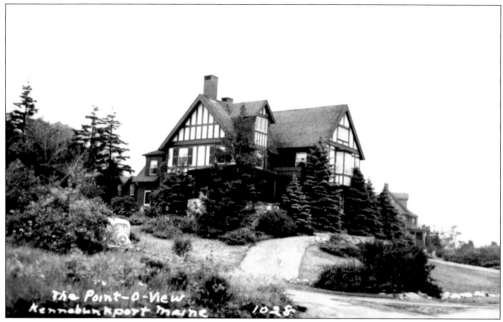

Built for B. S. Thompson in 1892, Point of View, shown here *c.* 1935, was designed by Boston architect Henry Paston Clark. Originally called Fort Bradford, it was Thompson's first cottage on Cape Arundel. When built, the cottage had gas, water, electric lights, and bells. Thompson also built the Billows in 1892, which he sold to Robert C. Ogden in 1904. Ogden was the head of Wanamaker's department store.

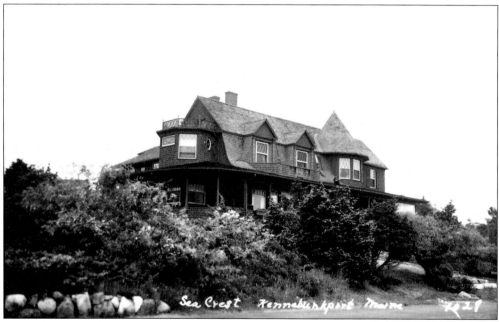

Pictured *c.* 1935, this cottage was constructed in 1895 for R. H. Platt, and was later owned by Daniel Woodruff, president of American Bank Note. Woodruff sold to John Somers in 1953, and he opened the cottage as a guesthouse called Seacrest. Somers operated the business until 1980, when he sold to Ann Fales, who changed the name to the Cape Arundel Inn.

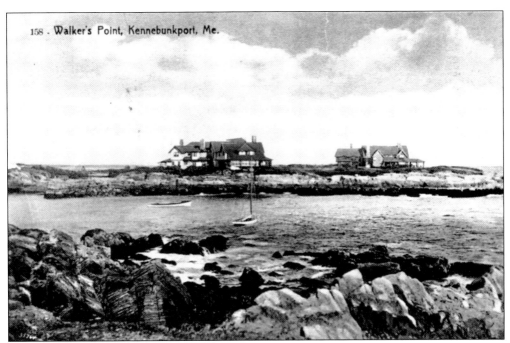

Walker's Point is seen here *c.* 1920. In 1902, wealthy St. Louis dry-goods merchant D. D. Walker purchased the 11-acre peninsula known as Damon Point off Cape Arundel. Previously, the point had been used as a public park, with trails and beaches. The cottage on the left was built for D. D. Walker in 1903. The cottage on the right was built for his son George H. Walker that same year. In the late 1960s, the D. D. Walker Cottage was demolished. Walker's Point has remained in the family and is now owned by former president George H. W. Bush, a Walker descendant, who uses it as a summer residence.

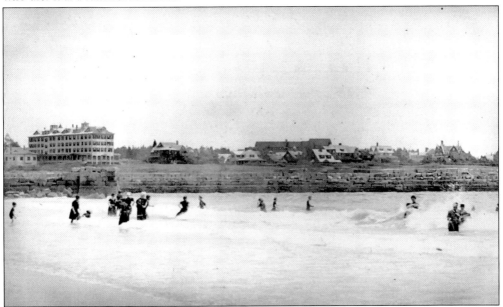

People bathe off the jetty in Cape Arundel *c.* 1910. The Cliff House is the building on the left in the background.

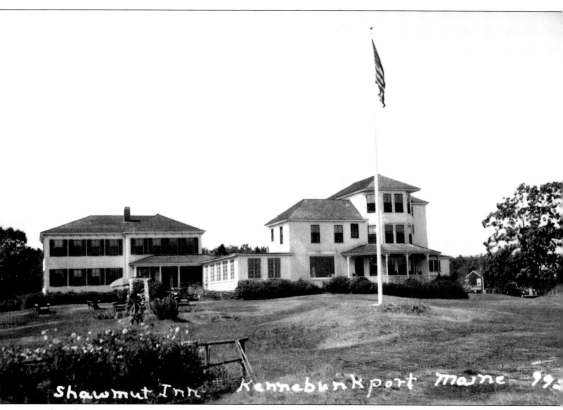

Shawmut Inn Kennebunkport Maine 99

The Shawmut Inn is pictured *c.* 1935. In 1883 William Rankin purchased the Wildes Pasture at Turbat's Creek from the Sea Shore Company. In March 1914, the *Kennebunk Star* reported, "A new hotel is being built at Turbat's Creek by Mr. Rankin of Waltham, Massachusetts." After Rankin retired in 1924, his daughters, Mary and Sarah, took over the hotel. Harry and Theophilla Small bought the property in 1946. The Smalls turned the inn into a sprawling resort that catered to upscale clientele. Their son, Frank, took over the business in 1965 after his father's death. Frank opened the inn year round, and it became known as one of the finest hotel-motel-restaurant complexes in the Northeast. Sadly, Frank died in 1974 at the age of 37. Ralph Bruno bought the property in 1989, but his plans to expand the inn fell through, leaving him and the business in debt. In 2000, a New York couple purchased the property and had the historic hotel demolished so they could build a private, gated summer estate. (Courtesy Greg Hubbard.)

Ten

CAPE PORPOISE

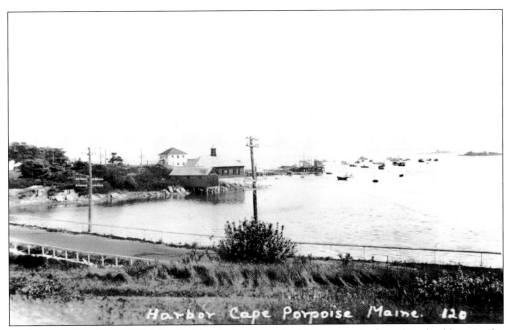

In this *c.* 1935 view of Bickford's Island, the Porpoise Restaurant is the white building in the center, and the old pier is on the right.

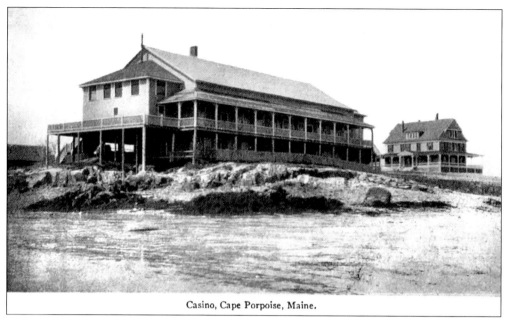

Casino, Cape Porpoise, Maine.

The Cape Porpoise Casino was built in 1900 as part of the electric railway, which later became the Atlantic Shore Line. The railway line made it possible for excursionists, usually workers and their families from the Sanford mills, to come to the seashore. The Cape Porpoise Casino, shown here *c.* 1910, had wide piazzas, a dance floor, a restaurant, and private dining rooms. It burned at the end of the summer in 1915.

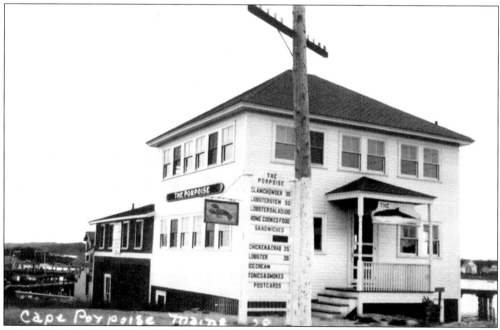

The Porpoise Restaurant, pictured *c.* 1935, was constructed *c.* 1930 for William H. Marland, who also had a cottage on Bickford's Island. The restaurant was later leased by Capt. Frank Nunan, who offered fresh baked goods and seafood to tourists and locals alike. In 1958, the Spicer family renamed the restaurant Spicer's Gallery and operated it until the 1980s. (Courtesy Louise Silberling.)

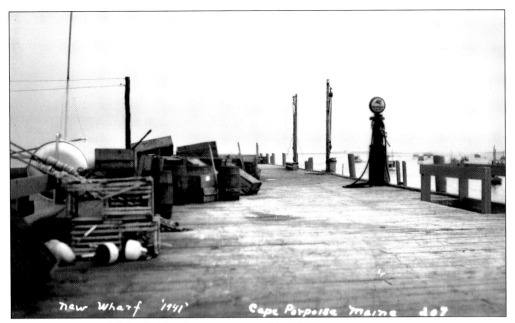

The new pier on Bickford's Island was constructed in 1941.

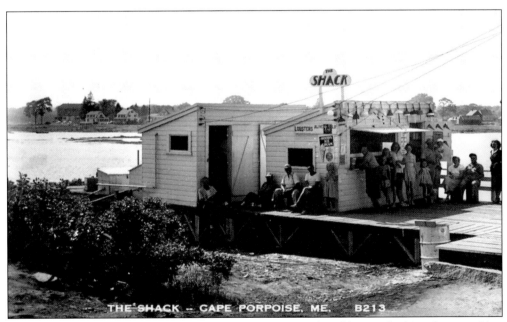

The Shack on Bickford Island is shown here *c.* 1955. Hazel Wildes was looking for something to do after she was laid off from the shipyard following World War II. So she opened a take-out restaurant that she named the Shack. Her husband, Sam, had been working on the pier since 1936. He operated a store there, and later managed the pier for Fredia Spicer, who owned most of the island and pier. Sam and Hazel worked at the pier for over 35 years.

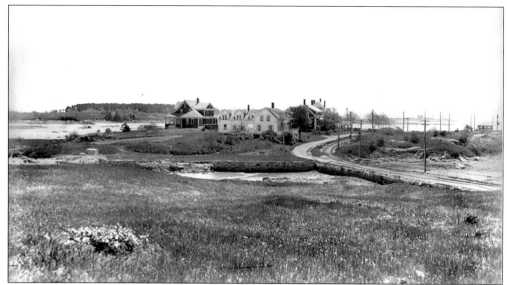

This *c.* 1915 view depicts Bickford's Island. The dark cottage to the left was built in 1903 for George Goodall of Sanford. The owner of Goodall Mills, he belonged to a group of men that created the Cape Porpoise Land Company in the 1890s. Their idea was to turn Cape Porpoise into another premier summer resort. They also created a port where coal and freight could be delivered and then sent by electric trolley to the mills in Sanford. The summer resort plans never materialized, and eventually Goodall bought the remaining lots and islands.

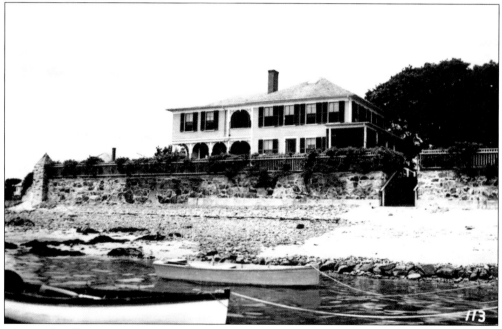

The Frank Allen Cottage, seen here *c.* 1935, is located off Pier Road on a private lane. The cottage was built in 1898, followed by construction of another for Frank's son Herbert. The Allen family called these homes the Wahwa Cottages, after a Sagamore chief named Tom Wawa (or Wahaunay), who had once lived at Kennebunk Beach. Both cottages are still owned by descendants of the Allen family.

SHILOH HOUSE,

CAPE PORPOISE,

KENNEBUNK-PORT, ME.

OLIVIA H. WHITE, Proprietress.

* THE * SHILOH * HOUSE *

is beautifully situated on a point of land at Cape Porpoise, Maine, and is

ONE OF THE MOST DELIGHTFUL PLACES ON THE SEA COAST.

This House stands within eighty feet of the water, and will accommodate forty guests. It is furnished with every modernized comfort and convenience, and is

One of the Finest Houses in Maine,

having been put in the most perfect order for the Season of 1887. A beautiful view of the Sea can be had from every room in the House.

A FINE AND HEALTHFUL SUMMER RESORT.

Good Fishing, Bathing, Boating, etc., and only twenty minutes ride from the Boston & Maine Railroad Station.

TERMS, from $1 to $2 per Day.

This is an 1887 advertisement for the Shiloh House. Miss Olive White purchased the Seth Pinkham home on Bickford's Island in 1887 and had a large addition built onto the old house. She opened it as a hotel called the Shiloh House. Soon after, White married and sold the hotel to John H. Bradley, who changed the name to the Waban House. On September 14, 1891, the hotel burned to the ground, but the furnishings were saved.

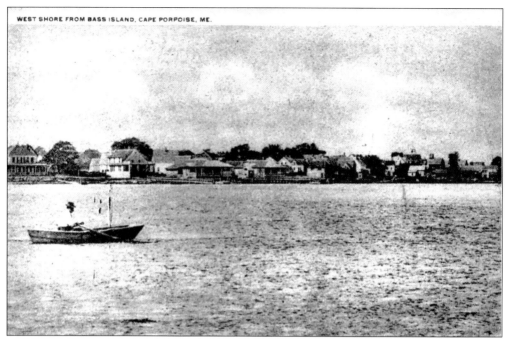

WEST SHORE FROM BASS ISLAND, CAPE PORPOISE, ME.

This early 1900s view shows West Shore from Bickford's Island. Langsford Road runs behind the buildings on the shore. Just visible on the right is the steeple of the Methodist church.

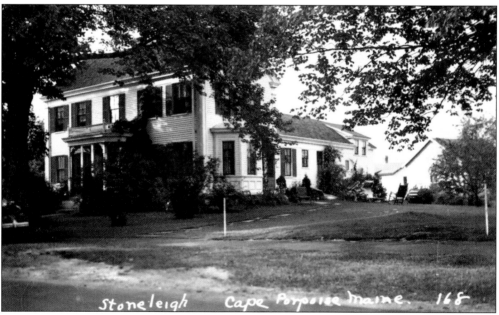

Stoneleigh Cape Porpoise Maine. 168

The Jedediah Towne House, built in 1852, was recently known as the Christmas House, a year-round gift shop. When this image was taken, *c.* 1935, the home was owned by Earl Stone and was called Stoneleigh. The house was originally built for Jedediah Towne, who had married Sarah Mitchell. Later, Towne's daughter married Seth Pinkham, and the couple's heirs sold the property to the Stone family.

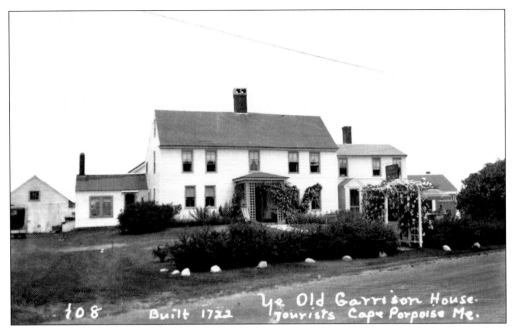

Located at the head of the cove on Pier Road, the Garrison House, seen *c.* 1935, was built in 1730 for Rev. Thomas Prentis, the first minister in Cape Porpoise. During the Indian wars, the house was used as a garrison to protect the families living in the area. John Millet purchased the home in 1798. The two small wings were added *c.* 1835, when the house was used as a duplex.

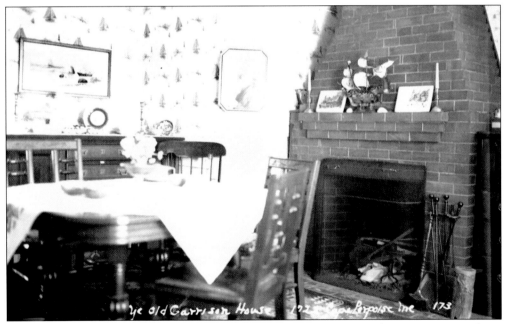

The Garrison House dining room is pictured *c.* 1935. At this time, the home was operated as a guesthouse by Maurice Leach, a descendant of John Millet. The Leach family sold the home in 1969 to Lyman and Louise Huff, who continued to operate the guesthouse for several years.

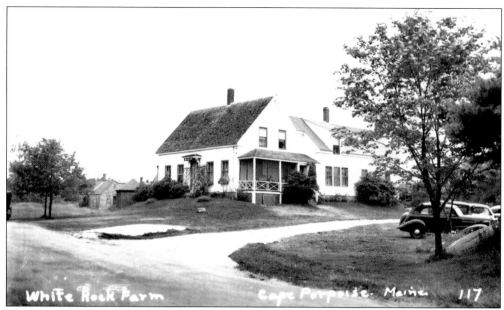

Shown *c.* 1935, the White Rock Farm was located on the corner of Marshall Point and Mills Roads. It was owned by Mrs. Lewis A. Dienstadt, whose husband had bought it in 1918 from George Hutchins. The Dienstadts used the property as a guesthouse. The home burned in the 1947 forest fire.

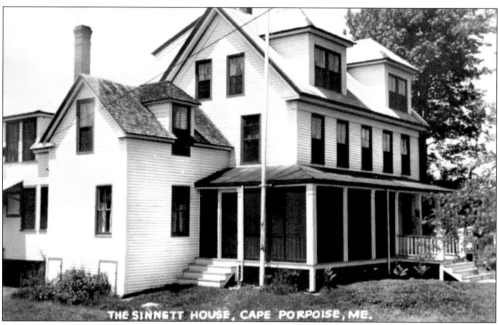

The Sinnet House on Langsford Road was built as a private home in 1868 by Edward and Robert Hutchins. Edward sold his interest to Robert in 1870, and in 1889, Robert swapped houses with William Sinnet. Sinnet wanted to open a guesthouse, and the Hutchins home was better suited to his needs. Eventually, the property included the 23-room main house, an 8-unit motel, and a cottage. Carl Dienstadt bought the property from William Clark in 1946, and operated the business until his death in 1963. The house survives today as an apartment complex.

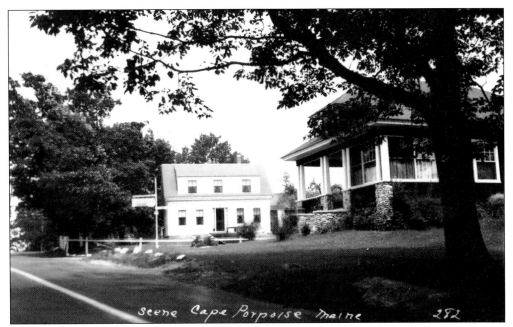

Mills Road homes are shown in this *c.* 1940 photograph. The cape in the back was built *c.* 1855, and was purchased by Frank Littlefield *c.* 1892. His granddaughter Ellen Littlefield Doubleday lives there today with her husband, David. The house in the foreground was built in 1936, and Wilbur and Rose Emmons lived there. Wilbur was a lobsterman who sold his lobsters in a garage behind the house. (Courtesy Kathy Ostrander.)

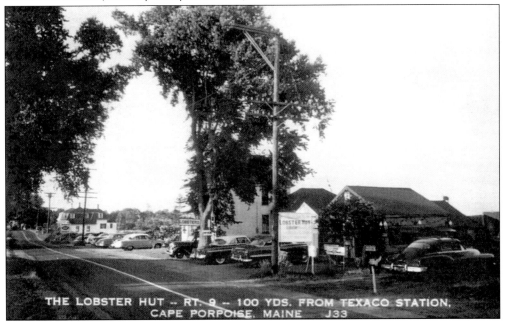

George Nunan and his wife, Pearl, started the Nunan's Lobster Hut in 1953. Nunan's is famous not only for its lobsters, but also for its two sinks in the dining room where patrons can wash up after eating. George Nunan's son Clayton and his wife, Bertha, took over the restaurant in the late 1950s and ran it for more than 30 years. Today, the business is still run by the Nunan family.

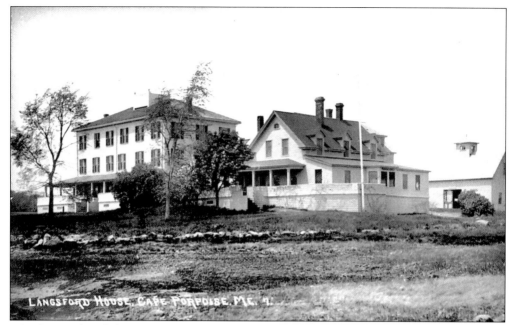

After he purchased the property from the Huff family in 1883, Henry Lewis Langsford opened the Langsford House, located at the end of present-day Langsford Road. It started as a small building, which later became the annex after several additions were constructed. Clement Huff had operated a salt-fish business on the site for a number of years.

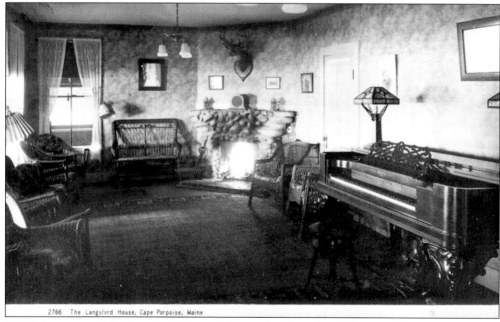

2766 The Langsford House, Cape Porpoise, Maine

The living room of the Langsford House is shown in this undated photograph.

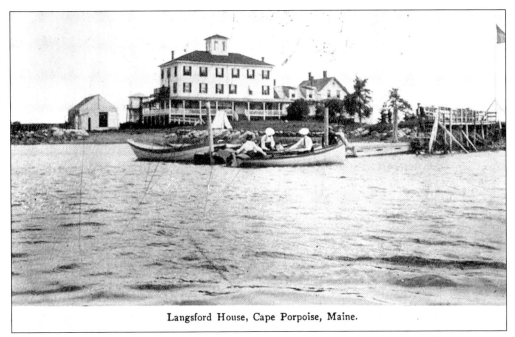

Langsford House, Cape Porpoise, Maine.

The Langsford House is seen from the water *c.* 1905. After Henry Langsford died, his son George assumed operation of the hotel. George built another addition in 1908, and later sold the hotel to Marshall Ryder in 1916. Ryder expanded the hotel again in 1936.

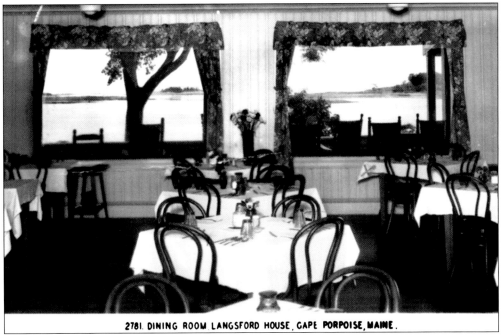

2781. DINING ROOM LANGSFORD HOUSE, CAPE PORPOISE, MAINE.

This *c.* 1945 view of the Langsford House dining room looks out on Cape Porpoise Harbor. George and Barbara Wood purchased the hotel in 1948 and operated it until 1964, when they had the hotel razed. The original house was saved, and parts of the hotel were converted into cottages. The rest of the property was sold off in lots.

Atlantic Hall is on the left in this *c.* 1935 photograph of Atlantic Square. After the casino burned, Cape Porpoise was left without a large meeting hall. The foundation for the hall had been poured in 1914, and the additional money needed to complete the construction was raised by subscription and donations. William and Marion Marland supported the project and hired the firm of Kilham and Hopkins to design the new hall. Completed in 1920, the new building housed the fire department on the first floor and a large hall on the second floor. Today, the town's library occupies the first floor. The dark, unpainted building in the background of this view is William Jennison's blacksmith shop, built in 1899. The small white building is Bradbury's fruit stand. Both buildings are now gone. (Courtesy Kathy Ostrander.)

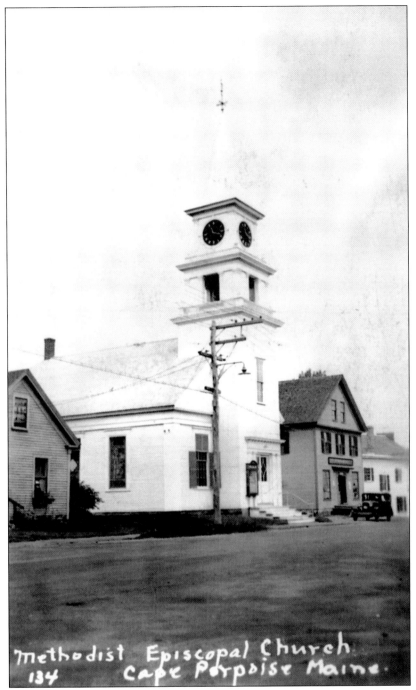

The Methodist church on Langsford Road is pictured *c.* 1945. Several residents who were members of the Methodist Church in Kennebunkport began holding meetings in a private home in Cape Porpoise *c.* 1838. In 1854 they officially formed a church and hired a minister. In 1856 church members bought a lot on today's Langsford Road, and wood for the building's frame was sawed at the Smith Brothers Mill on the Baston's River, off Mills Road. Aaron Mellon built this church, which opened in April 1857.

CAPE PORPOISE'S NEW I. G. A. STORE -- CAPE PORPOISE, ME. C129

Bradbury's Market, shown *c.* 1955, is still the center of life in Cape Porpoise today, as it houses the town's post office. The building was constructed in 1899 by Luman Fletcher, who operated a grocery store there. After Fletcher's death in 1920, his wife ran the store until 1939. In 1942, Frank Bradbury and his son Wilbur bought the store, and later Milton "Charles" Bradbury joined his father and brother in the business. The Bradburys sold the market in 1977, but in 1987, Tom Bradbury and Steadman Seavy, Frank's grandsons, bought the store back into the family. A good history of Bradbury's Market can be found in the book *Woven Together in York County, Maine: A History 1865–1900*, by Madge Baker.

BIBLIOGRAPHY

BOOKS

Baker, Madge. *Woven Together in York County, Maine: A History 1865–1900.* Shapleigh, ME: 1999.

Bourne, Edward E. *History of Wells and Kennebunk.* Portland, ME: B. Thurston and Co., 1875.

Bradbury, Tom and Pamela Wood, eds. *Across Generations: 350 Years of Life in Kennebunkport.* Kennebunkport, ME: Town of Kennebunkport, 2003.

Brooks, Annie Peabody. *Ropes' End.* Kennebunkport, ME: 1901.

Butler, Joyce. *A Kennebunk Album.* Kennebunk, ME: Rosemary House Press, 1984.

———. *Kennebunkport Scrapbook Vol. II.* Kennebunk, ME: Rosemary House Press, 1989.

Dow, Joyce Wheeler. *Old-Time Dwellings in Kennebunk Port.* Kennebunk, ME: Star Print, 1926.

Fales, Dean A. Jr., ed. *Antiqueman's Diary.* Gardener, ME: Tilbury House, 2000.

Freeman, Melville C. *History of Cape Porpoise.* Cape Porpoise, ME: 1955.

MacAlister, Lorimer W. *Chronicles of Cape Porpoise and Kennebunkport.* Kennebunk, ME: Press of Arundel, 1949.

Magnuson, Rosalind. *Quiet, Well Kept, for Sensible People: The Development of Kennebunk Beach 1860–1930.* Kennebunk, ME: Brick Store Museum, 2000.

Perkins, Lauraette. *History of Cape Porpoise and its Houses.* Unpublished manuscript. Cape Porpoise, ME: Cape Porpoise Community Library.

Remich, Daniel. *History of Kennebunk.* Copyright Carrie Remich. Private Printing, 1911.

Schmidt, Henrietta. *Through the Years.* Kennebunk, ME: Star Press, 1975.

Scott, Connie Porter. *Kennebunkport.* Augusta, ME: Alan Sutton, Inc.

Tobin, Patrice S. *The Kennebunkport Playhouse: A Brief History.* Kennebunkport, ME: Kennebunkport Historical Society, 1991.

BROCHURES

Lovejoy, Kim E. *National Register of Historic Places Inventory for Cape Arundel.* July 1984. (Maine Historic Preservation Commission, 55 Capital Street #65, Augusta, ME 04333.)

Morang, Bruce. *Journal of the Kennebunks.* 1950.

NEWSPAPERS

Journal Tribune. Biddeford, ME: 1890–1950.

Kennebunkport Items. Kennebunkport, ME: 1917.

Portland Press Herald. Portland, ME: 1960–1999.

Wave. Kennebunkport, ME: 1885–1910.

York County Coast Star, also known as *Eastern Star* and *Kennebunk Star.* Kennebunk, ME: 1885–1999.

ARTICLES

Butler, Joyce. "Home from the Seas: Kennebunkport's Fabled Sea Captain." *Chapters in Local History,* Vol. 3 No. 1. 1990.

"The Development of Walker's Point." *Chapters in Local History,* Vol. 2 No. 2. 1986.

"The Development of Walker's Point." *Chapters in Local History,* Vol. 2 No. 2. 1989.

Joy, Ken. "Out of the Past." *York County Coast Star.* 1963–1975.

COLLECTIONS

Andrew Walker Diaries. Kennebunk Free Library, Kennebunk, ME.

Brick Store Museum, Kennebunk, ME.

Kennebunkport Historical Society, Kennebunkport, ME.

ACKNOWLEDGMENTS

I would like to thank everyone who loaned photographs for this book and who gave time for interviews. Most importantly, I am grateful to Kathy Ostrander for all her help, including filling in missing images, scanning, and locating important information. Again, as with my first book, it would not have been possible to write this without the resources of the Brick Store Museum and the Kennebunk Free Library. The Kennebunks are so fortunate to have these institutions. The museum's archives and collections are amazing and extensive. In addition to the new library and the well-organized collections, the staff, comprised of volunteers Kathy Ostrander, Rosalind Magnuson, and Kathryn Hussey, were very helpful. The resources of the Kennebunk Free Library, especially the *York County Coast Star* microfilm dating to 1878, the Andrew Walker diaries, and the Maine Collection, were important as well. I am also grateful to Greg Hubbard, who allowed me to draw from the unpublished manuscript we completed.